UNSEEN HASTINGS AND ST LEONARDS

FREDERICK CROUCH

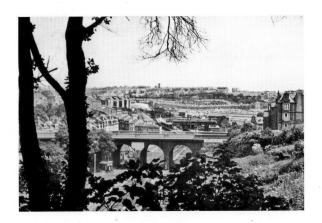

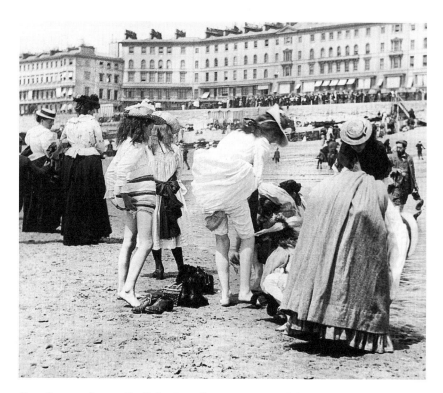

On the sands at Carlisle Parade, 1903. Mixed bathing was not allowed on the beach before 1900. After Queen Victoria died in 1901 the social scene relaxed. The girls pictured here are casually tucking up their skirts in this relaxed Edwardian view.

First published 2016

The History Press
The Mill, Brimscombe Port
Stroud, Gloucestershire, GL5 2QG
www.thehistorypress.co.uk

© Frederick Crouch, 2016

British Library Cataloguing in Publication Data.
A catalogue record for this book is available from the British Library.

ISBN 978 0 7509 6748 8

Typesetting and origination by The History Press
Printed and bound by CPI Group (UK) Ltd

CONTENTS

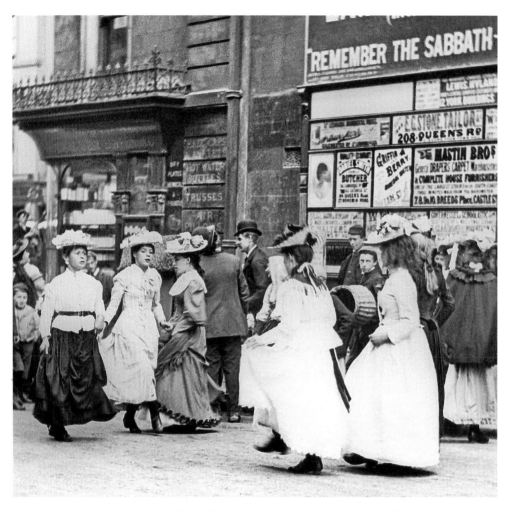

Girls dancing at the bottom of Cambridge Road on May Day 1903. The fashions are Edwardian. The shop on the left was a tobacconist that still trades as a newsagent and sweet shop. The hoarding on the wall behind the dancers is exhorting passers-by to 'Remember the Sabbath'. There is an advert for the Mastin Bros shop at Breeds Place.

INTRODUCTION

Down through the generations Hastings has received many visitors, from William the Conqueror to the crowds of foreign students who throng the town in the summer months.

The eroding cliffs to the east and the High Weald area of outstanding natural beauty to the north made old Hastings unsuitable for industrial development, but make it a beautiful holiday destination and a marvellous location for the artist, writer and photographer.

The stage coach took seven hours to reach Hastings from London, but when the railway station opened in 1851 it transformed Hastings from a little fishing town into a modern seaside resort attracting thousands of holidaymakers. Over the next twenty-five years new streets were built around the site of the old Priory Bridge in all directions. Priory Meadow was drained in 1838 by running an iron culvert from the Priory Bridge to the sea. A pedestal with three lamps was placed at the site of the old bridge. The 90ft Albert Memorial Clock Tower was subsequently erected where the bridge had once been. The 'Memorial', as the area became known, came to symbolise the new town centre of Hastings that the railway had created. Developments continued with the Castledown Estate being sold in 1853 and Priory Farm demolished in 1872.

One of the first speculators to gain from the opening of the station was a wealthy London merchant called Patrick Francis Robertson, who in 1849 leased the area previously known as the 'America Ground'. In 1853, the wooden Claremont Steps were rebuilt in granite and the new street near Holy Trinity church was named Robertson Street, which became a great favourite with photographers. Many businesses moved from the Old Town to the streets around the Memorial, but the area suffered from the nuisance of flooding, which has continued until recent times. The last incident affected the Priory Meadow Shopping Centre.

Hastings is well known as a member of the Cinque Ports in the thirteenth and fourteenth centuries, but now only Rye has a working harbour. There was a plan to build a harbour at Hastings in 1838 and Hastings Station was originally built as a terminus for a cross-channel service to Dieppe, but the scheme, which would only have been able to accommodate small boats, came to nothing.

The fun with an old photographs book is trying to work out when and where the pictures were taken. Since the invention of photography, the camera has followed changes in architecture, occupations, tourism and fashion. You can tell when a photograph was taken by knowing the type of camera and developing process which was in use at the time. The clothes people are wearing, the street signs and the style of architecture shown are also all important clues. Zebra crossings, for example, were not invented until after the Second World War, so any picture with a zebra crossing in it must be post-war. The last Hastings tram ran in 1929 and the last trolley bus in 1959.

The earliest-known photograph to be permanently fixed was taken by a camera obscura in 1826, but photography of Hastings did not begin until the wet collodion process was invented in 1851. This very early photographic process required a time exposure and anything which moved during the exposure would come out blurred. This is the reason why very early photos of the town have no people in them. However, collodion is fast enough for snapshots in good light and failures are few. Dry plates made of thin glass coated with a faster emulsion were invented in 1871, but they are fragile and only professional photographers could use them. During this early period, photography was limited to formal views and poses where everybody had to stand still.

In 1889, George Eastman marketed a small hand camera which used a roll of film and provided a developing and printing service. This meant the photographer need not get involved with chemicals. He called this camera the 'Kodak' and this name became very famous. Indeed some excellent Kodak slides of Hastings taken in the 1960s feature in this book.

There are many views in this book which will delight the 'then and now' enthusiast. I have tried to keep to the theme of 'Unseen Hastings' by including as many previously unpublished pictures as possible, but a few pictures which have appeared elsewhere are included for comparison purposes. I have also arranged related views so you can enjoy a walk around the town with your camera or mobile phone. Better pictures can be obtained with a small camera if you always remember to hold the camera perfectly still.

The golden cliffs of Hastings with their green hills beyond and the sea and fishing boats provide the perfect subject for the artist. Where Lovers Seat once stood, only the sea now crashes against the rocks which remain, but artists and photographers have recorded images of those lost times which we can still enjoy today.

All images are from the author's collection, which is housed in the Local Studies Room at Hastings Museum.

ABOUT THE AUTHOR

Now retired from teaching, Frederick Crouch was previously a member of Sussex Archaeological Society and Hastings Area Archaeological Research Group. He has had a long association with Hastings Museum and the local history of the area. An honours graduate of the University of Sussex where he studied historical geography, he participated in digs at the Roman Bath House at Beauport Park and elsewhere in the Hastings area. Apart from photography, his current research interest is place-names in the landscape and their influence on the history of the area. He lives in Hastings.

1

CASTLE HILL

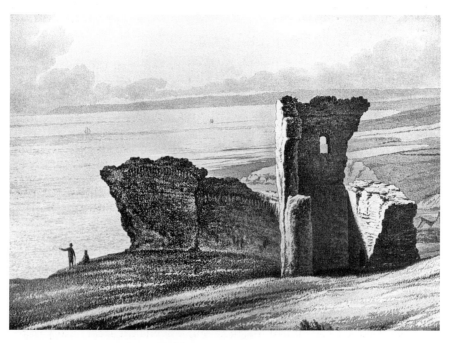

Remains of the castle, 1817. Nowadays it appears as a romantic ruin, but castles such as this were an essential feature of the Norman policy, which needed to demonstrate power and dominance. The castle was built later than 1066 and is not the temporary fort depicted in the Bayeux Tapestry; that fort was constructed on land south of White Rock and is now lost to coastal erosion.

Priory Valley from the castle, 1870. Priory Farm, which was pulled down in 1872, can be clearly seen behind the chimney. Behind the farmhouse the road goes up round the tunnel because Cornwallis Bridge had not yet been built. You can just make out the station on the extreme right of the picture with Havelock Road leading to it. The lower road is Station Road, which now runs into Priory Meadow Shopping Centre.

The Central Cricket Ground, 1974. In this view, Winterbourne Close is still Hickman's Field. The demolished Engine Shed, Goods Shed, the 1930s station building, Station Road, and Middle Street are all in evidence.

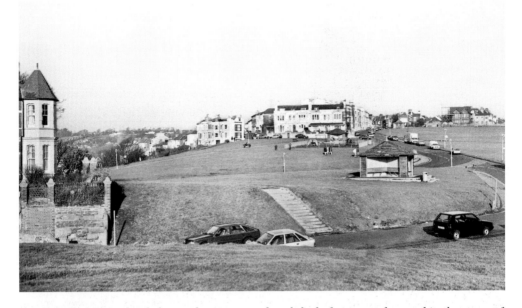

Castle Hill, 1980. The shelter in this view was demolished after it was damaged in the storm of October 1987. The four sides allowed you to sit in the sun and out of the wind according to the weather and time of day. The identical shelter in the distance was repaired, but with only a single internal wall which provides less protection.

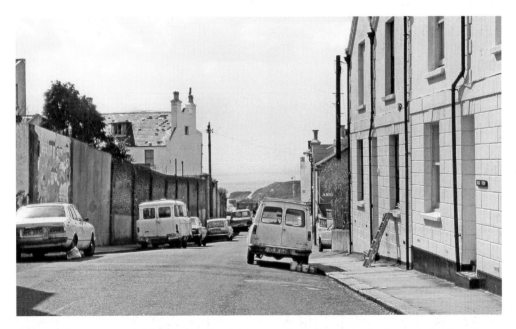

Number 1, Plynlimmon Road, 1970. This view is looking in exactly the opposite direction to the previous photograph. It was the residence of Kathleen and Bob Noonan (author of *The Ragged Trousered Philanthropists*) in 1901 when they first came to Hastings. This also looks as if he might have left his stepladder against the windowsill!

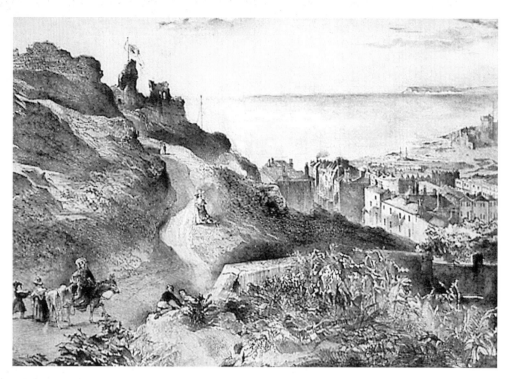

Entrance to the castle, 1830. The original entrance to the castle was across a bridge from the Ladies' Parlour, but that proved too dangerous in high winds, so this alternative entrance was made and has remained the entrance ever since.

Castle Hill Road in 1977. Looking in the opposite direction to the previous view, this road was originally part of the defensive ditch that ran round the castle.

Opposite: **Castledown House in Castledown Avenue, 1970.** This house became a grade II listed building in 1975. It was built in 1831 on part of the old Castle Farm fields, known as Wellscroft and Cognore, by the Revd William Wallinger, who was the first incumbent of St Mary-in-the-Castle, 1828–34. He sold it in 1834 for £3,500 and a row of houses was built in the garden, spoiling its situation. It was converted into flats, but it suffered from a serious damp problem and subsequently stood derelict for many years. Eventually, it had to be demolished.

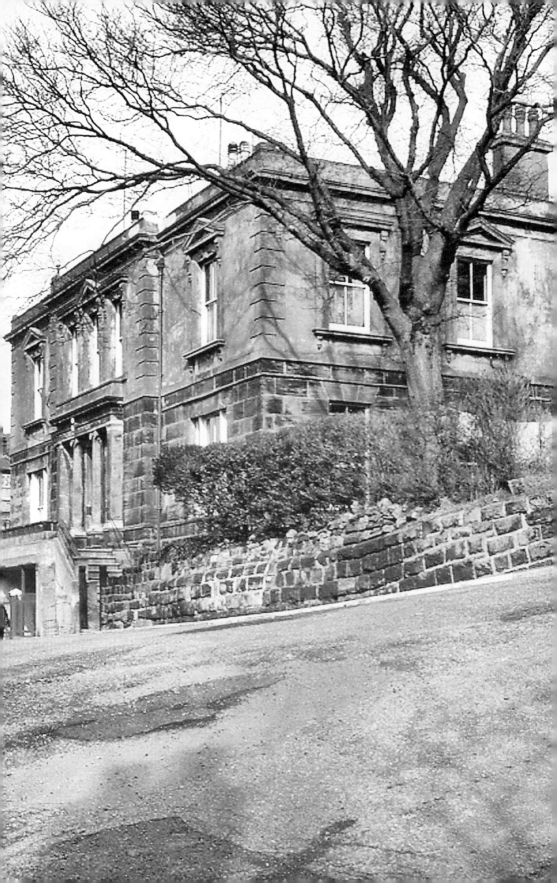

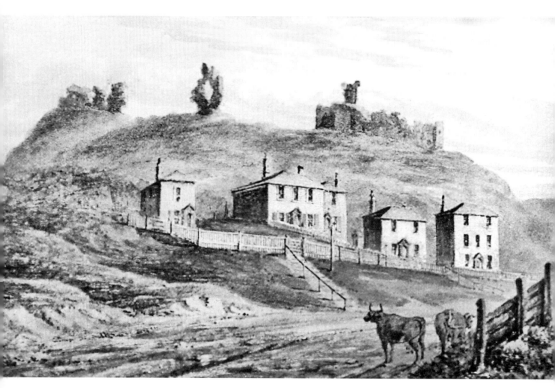

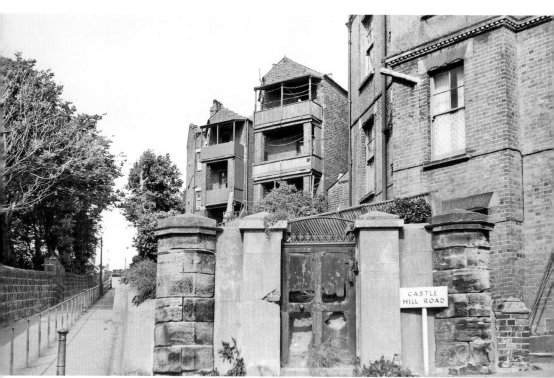

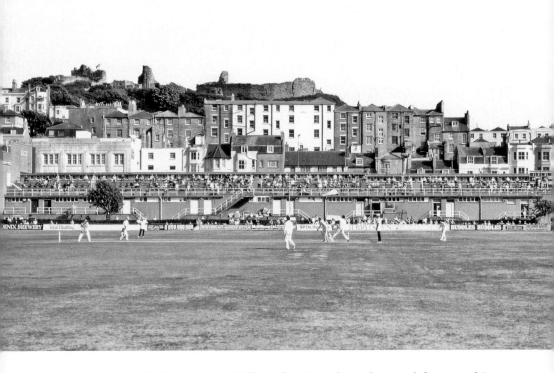

Opposite top: **Castle Farm, Castle Hill Road, 1818.** This is the site of the original St Andrew's church. The houses on the right in this picture appear on the extreme left in the picture above.

Opposite bottom: **A rather haunting 1959 view of Wallinger's Walk.** This walk was named after the first owner of Castledown House. The derelict door, which has now been bricked up, was the original entrance to the garden of Castledown House. The houses behind, which you would expect to have been demolished, have now been rebuilt, but Castledown House is no more.

Above: **The castle from the cricket ground, 1989.** The rear of Queen's Parade is in the background. The houses that are depicted in the watercolour on top left on the opposite page are on the extreme left of this picture.

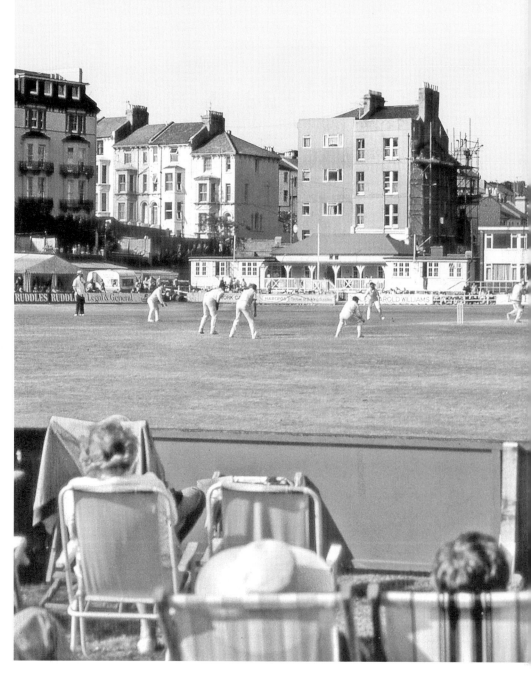

The cricket ground, 1989. This view of the last cricket match ever played here shows the pavilion and South Terrace.

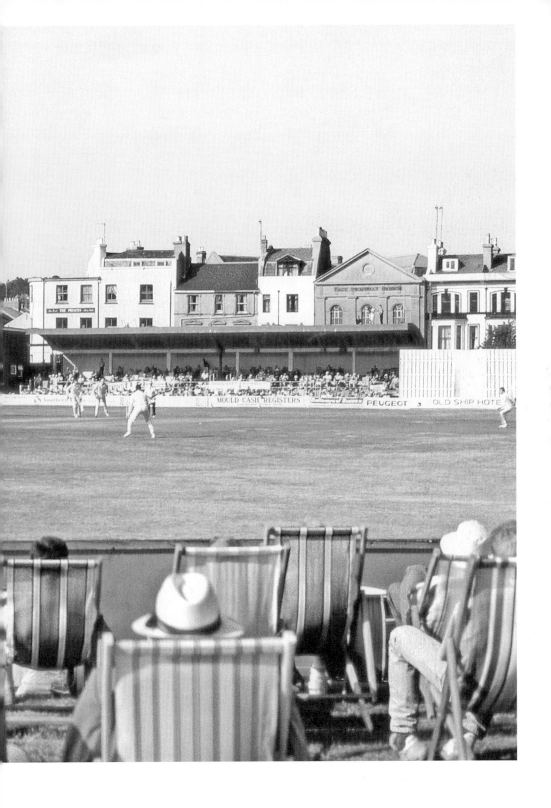

15

Wellington Square in the 1960s. This was originally known as Wellington Place.

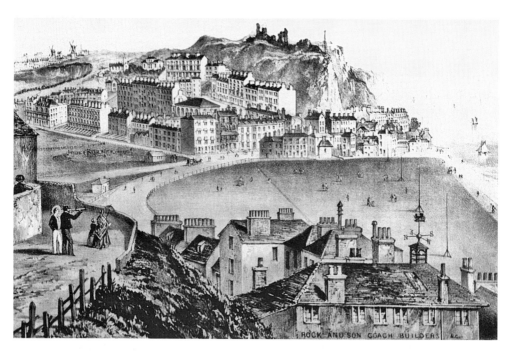

Wellington Square from St Michael's Place, 1838. The Priory Bridge has gone, but the America Ground has yet to be built on.

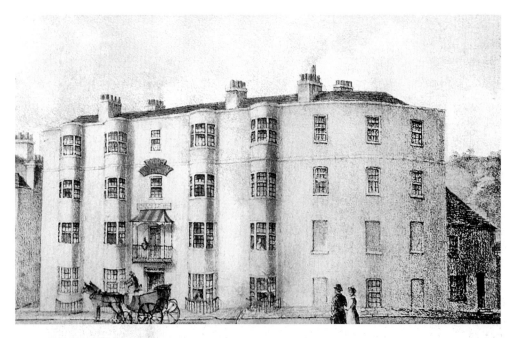

Castle Hotel in 1816, as it was originally built. The hotel had a coach house with extensive stabling to the rear. The road up Cuckoo Hill, subsequently Cambridge Road, is depicted on the top right.

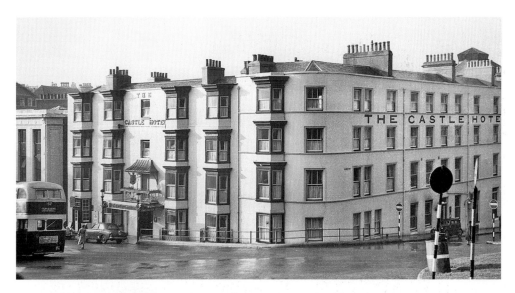

The Castle Hotel in 1957. The facade, although it is in keeping with the rest of the hotel, has been altered from the original shown in the previous picture. This meant that it was not a protected listed building and could be sold for redevelopment and demolished in 1967. A Tesco supermarket was built on the site. This subsequently moved to Church Wood Drive where it still is. The building on the extreme left is the Woodhouse furniture shop opposite Woolworth's on pages 60–61.

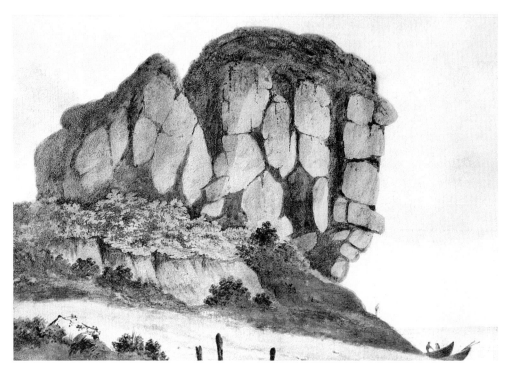

The Castle Rock, 1807. The rock, which appears in the next picture with a flag on top of it, was situated on the corner of Wellington Square and Castle Hill Road. It was quarried for stone and finally removed.

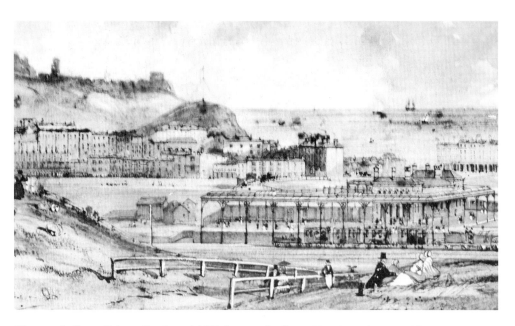

The castle from Priory Station, 1857, later rebuilt as Hastings Station. This picture is from an old watercolour.

2

THE OLD TOWN

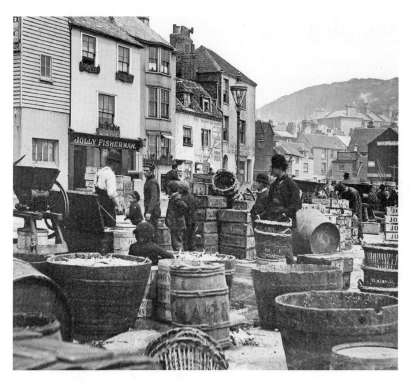

The fish market at East Beach Street, 1898. The man on the right, who looks like a policeman, is a fishmonger who is wearing the bowler hat that was standard attire in those days. The fishermen and the 'boys ashore' are wearing caps. The Jolly Fisherman Inn was closed as licensed premises in 1959, but continues to trade as a B&B and cafe.

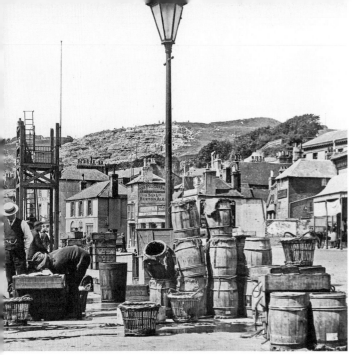

The fish market, 1898.
The catch, which would have been herrings, were sold in barrels and were smoked to preserve them. The structure on the left with the ladder is the harbour lights, which would be lit at dusk to guide boats into the harbour. They were operational at the time this photograph was taken. The disused lower light is on the extreme left of the picture, behind the man in the straw hat. The house with three upper windows is the Old Customs House.

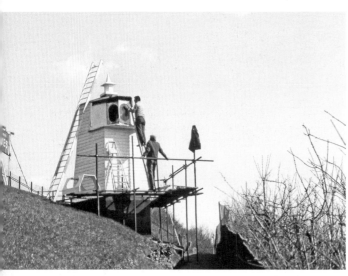

The Upper Light on the West Hill, 1980. The lenses are being cleaned; an important job as the light needs to be seen far out at sea.

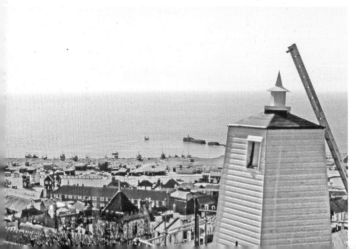

The Upper Light, 1980.
This light, built in 1851, was deliberately positioned directly above the Lower Light. The lights depend on a principle called parallax in which the apparent alteration of the relative position of the two lights is dependent on the viewpoint of the boat approaching the harbour. When the lights are in alignment, the fishing boats know it is safe to approach the harbour avoiding any hidden rocks. In the modern era, the lights are lit automatically by electricity.

East Parade, 2015. The disused Lower Light in East Parade on the left is now part of a cafe. It was rebuilt in 1827 to a slightly different design having originally had a lantern on top (see page 42). The light was moved to the lifeboat house in 1882. That was demolished in 1959 and the light moved again to the south side of the boating lake. It displayed red to distinguish it from the town lights.

Bottom of High Street, 1959. The number 11 bus is going to Silverhill. The Rock and Ices shop remains popular, although it has changed hands several times.

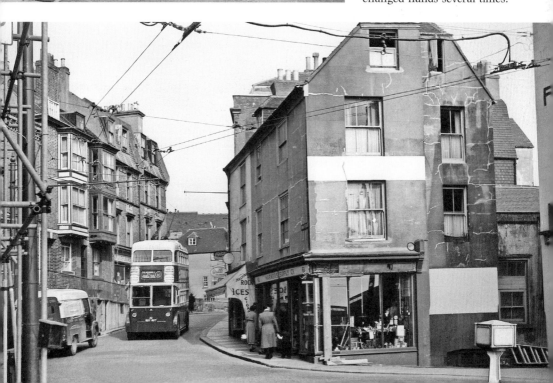

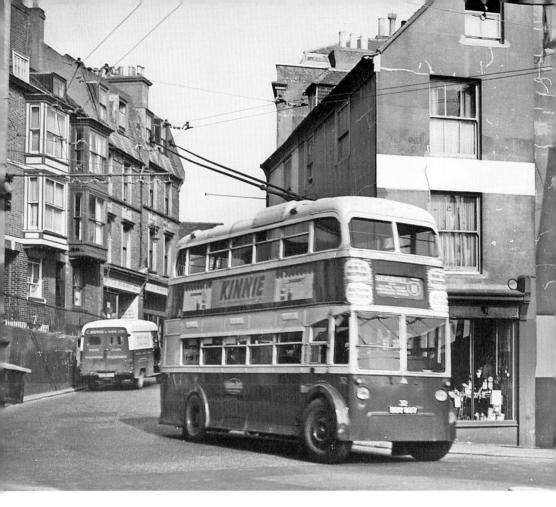

Above: **High Street, 1959.** In this view the bus has made further progress. Before the Bourne was built, the High Street was the main A259 road to Rye and all traffic had to go through this narrow street. You can still get fish and chips at the shop on the extreme right, which has now been rebuilt and trades as the Blue Dolphin.

Above right: **The Swan Inn at the bottom of the High Street looking towards the sea, 1890.** This was the town's greatest and most popular hostelry. It had a long and illustrious history being the destination for coach travellers from all over the country since 1523. It was destroyed by a bomb during Sunday lunch on 23 May 1943, killing everyone inside. (There are no 'unseen' photographs of The Swan, but this has been included as a reference to the image below.)

Right: **High Street, 1959.** The Swan Inn was never rebuilt and a part of the site was left as a garden in memory of the twenty-five people killed. Flats have now been built on the part of the site that was left to go wild. The trolley bus is the number 11 to St Helen's.

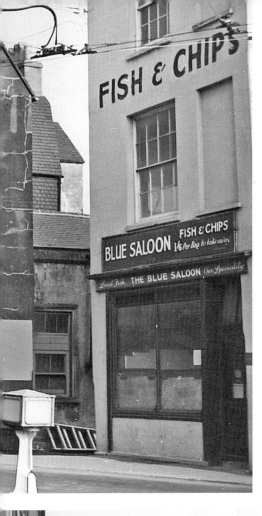

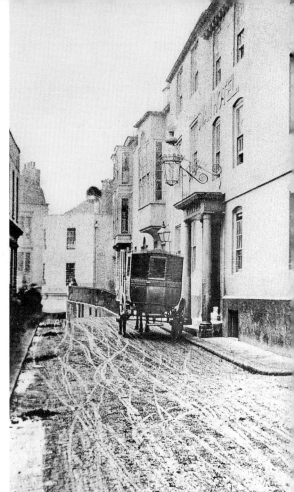

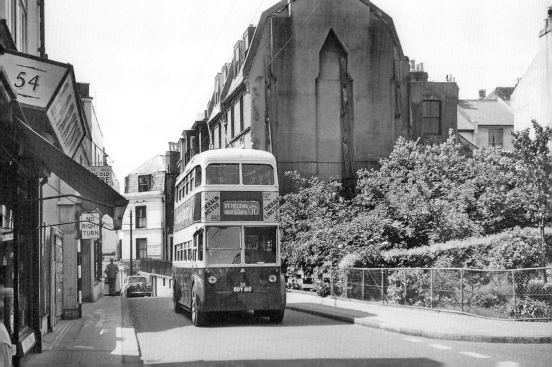

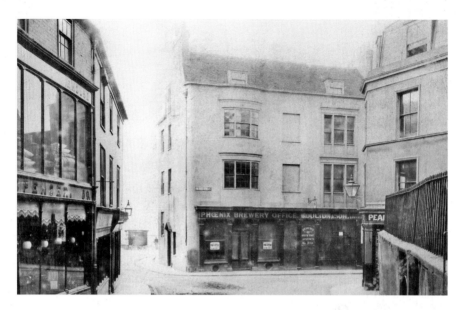

High Street, 1900. The entrance to George Street at the bottom of the High Street showing the Phoenix Brewery Office, now demolished.

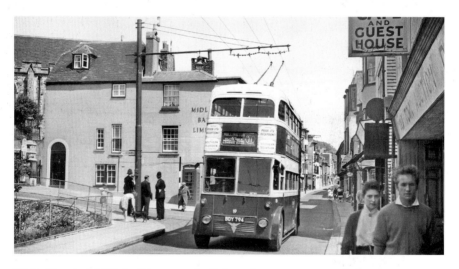

High Street, 1957, looking north. Before the construction of the Bourne A259 trunk road, all through traffic had to go through the High Street, which makes this a very historic shot. Two policemen are on the corner while a girl strokes a dog.

Opposite top: **St Clement's church from Hill Street, 1930.** This church is famous for having a cannonball embedded in the tower. It is said to have been fired from one of Admiral De Ruter's ships during a Dutch raid.

Opposite bottom: **Swan Terrace and Hill Street, 1963.** Swan Terrace was named after the famous Swan Inn shown on page 23. Hill Street was originally known as Bullockes Hill because there was a slaughterhouse here, demolished in 1581. This looks like a modern photograph, but the railings on the high pavement show that it is not.

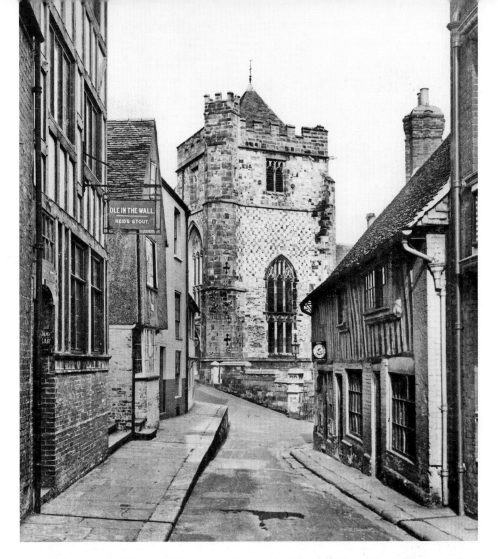

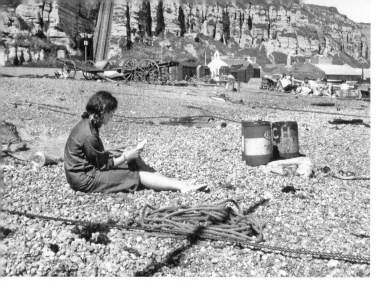

Hastings School of Art student, 1963. She is sketching fishing boats while a family enjoys the sun. The School of Art was in the Brassey Institute in Claremont.

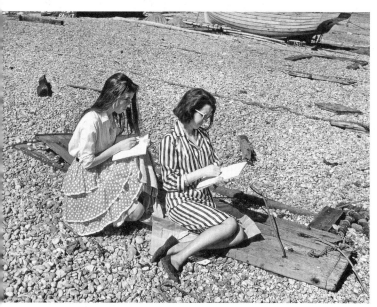

Art School Students, 1963. The girl on the left is wearing a polka dot skirt, while her companion is wearing a black and white candy-stripe dress.

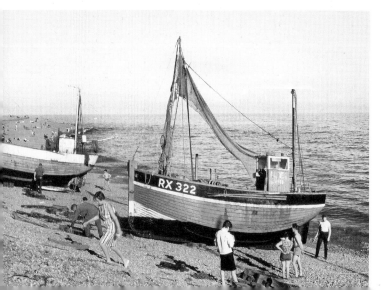

RX322, 1966. The fisherman is putting sledges on the ground to allow the boat to be winched up the beach. The 'RX' denotes where the fishing boat is registered, in our case it is Rye Sussex.

Fishermen repairing nets on board a lugger, 1975. The flags are dropped into the sea to denote where the nets have been laid. The East Hill is in the background.

Old Town arm wrestling contest, 1903. There is a queue of customers willing to take on a man who would be a professional wrestler. There is a band on the right-hand side and some sea cadets with them. The men on the left in straw hats are placing bets on who is going to win. The gentlemen who are not taking part are standing outside the roped off area on the other side with their lady friends.

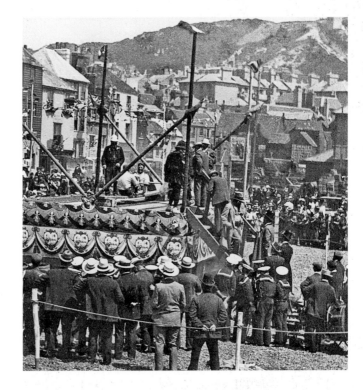

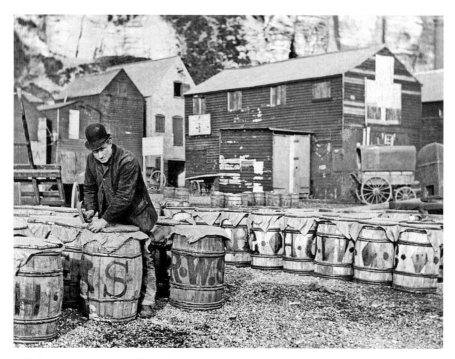

A fishmonger packing barrels on the Stade, 1890. Rock-a-nore Road is visible in the background. The wooden buildings you see here were destroyed in a fire.

RX58 about to be hauled up the beach, 1966. The bow of RX322 is just visible on the right.

Croft Road, 1962. This was originally Marlpit Lane, the main way to the West Hill. It was called Croft Lane in 1819, the upper part being the Hill Lane. This is a 'then' view. 'Now' it is jam-packed with parked cars. The interesting thing, however, is that it is the location of the picture shown below.

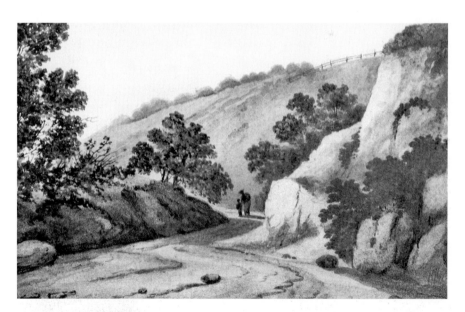

Croft Road, 1808. The Coney Banks in Croft Road as shown in the picture above. Rabbits were introduced by the Romans, and later by the Normans, as a useful source of meat and fur. The main warren was above St Clement's church by the West Hill; it was owned by John Collier, and then Edward Milward.

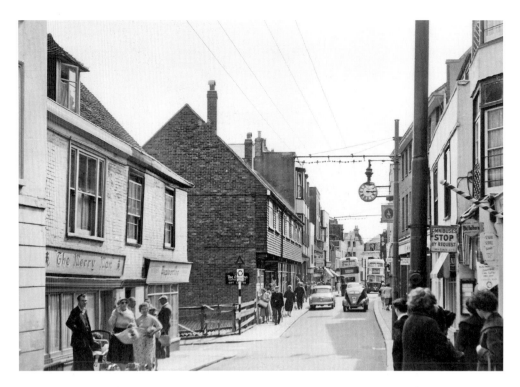

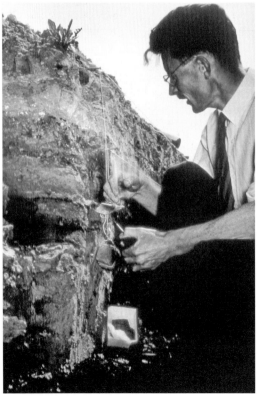

High Street, 1959. This view of the High Street is easy to recognise. The trolley bus coming up has to wait at Hill Street for the bus going down. On the right, passengers are waiting at the bus stop while onlookers on the left are watching the photographer.

Excavations in the High Street, 1953. John Manwaring Baines was the curator of Hastings Museum from 1935 to 1973. He wrote many pamphlets, but is probably more widely known for his comprehensive book on the town, *Historic Hastings*. He and his wife came to Hastings from Yorkshire. He was one of the founders of the Old Hastings Preservation Society (OHPS), the Burton's St Leonards Society, the Hastings Area Archaeological Research Group (HAARG) and he was a member of the Wealden Iron Research Group (WIRG).

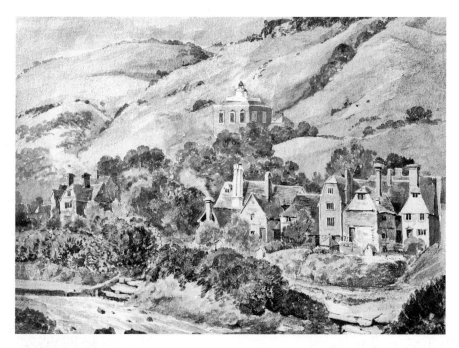

Hastings House perched above All Saints' Street, 1815. The Bourne Stream can be seen in the foreground. Hastings House had many famous visitors, one of whom was Lord Byron, who is said to have thrown a bottle of ink out of the window in a fit of temper. The house was approached by a curved path and had a small garden at the front with a sundial.

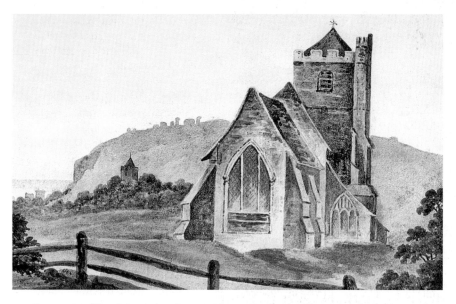

St Clement's church and Castle Hill from All Saints' church, 1808. This church replaced the earlier All Hallows which stood on the site of the Lord Nelson pub. It was rebuilt in 1870.

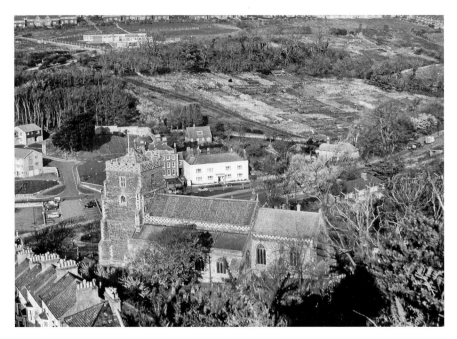

All Saints' church with Torfield House and Tor Field in the background, 1971.
Torfield School is at the top left. Old Humphrey Avenue is to the bottom left of the
picture.

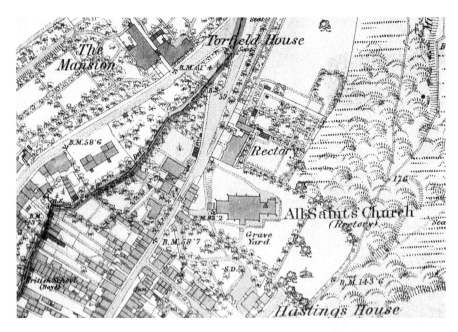

Hastings House, 1850. This map shows where Hastings House (not to be confused
with Old Hastings House) was in relation to All Saints' church, The Mansion, and
Torfield House. The map shows the garden with the sundial, marked 'SD'.

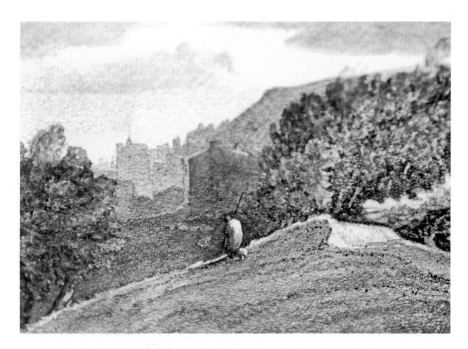

A view of the Old Town from Torfield, 1808. A shepherd is in the foreground. The name Torfield was spelt 'Torsfyld' in 1559, the earliest reference. It was subsequently spelt 'Terresfield' (1619), 'Tarrfeild' (1651), and 'Terry High Field' (1955). 'Terre' means an 'earth' field for digging and it is still used as allotments – no mystical connection with the Norse god Thor.

The Minnis Rock, 1974. The rock is a post-historic antiquity carved by a local stonemason.

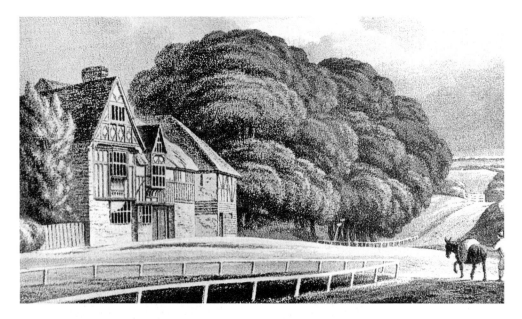

The Slough, 1815. The house in the background, which appears in the picture below, has a sign on it referring to Titus Oates, but he actually stayed in the house in the foreground, which has been demolished.

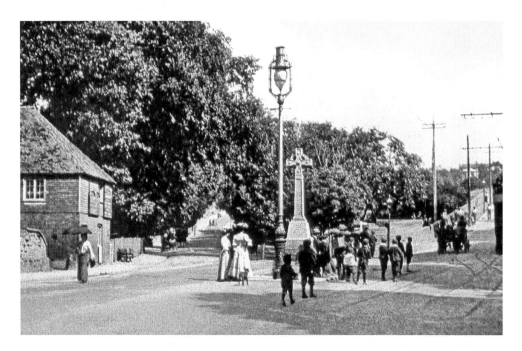

The Slough, 1908. The bottom of Old London Road and Harold Road showing the Celtic Cross that was erroneously called the Market Cross. The mistake was made by an artist who copied a map of 1746 for a paper in the Sussex Archaeological Collections. He thought the symbol for the sluice was a market cross.

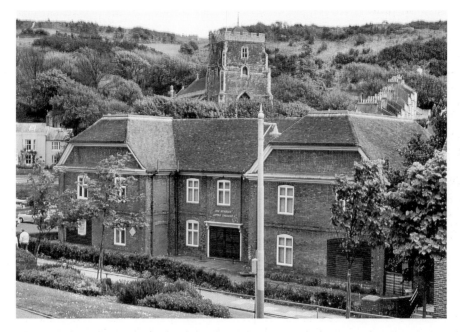

The Stables Theatre, 1975. This looks like a modern view, but the old trolley bus pole, with the finial that has been converted into a lamp post, gives it away. These stables originally belonged to 'The Mansion', now Old Hastings House.

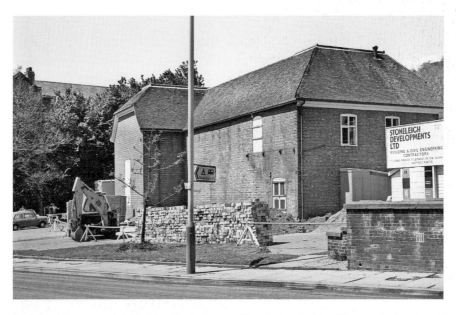

Stables Theatre, 1977. The High Street side of the Stables Theatre is listed and cannot be altered. An architect once proposed making the Stables the foyer of a much larger theatre. Dick Perkins, the then chairman, joked, 'Had we gone with him we would be where Glyndebourne is to-day!' The Stables hired another architect. In this photograph, a pile of bricks awaits the builders of the more modest extension.

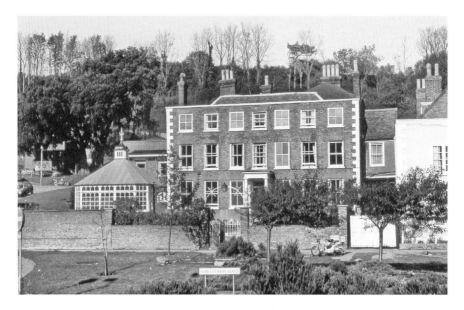

Old Hastings House, 1980. The house was rebuilt and sold to John Collier for £300 in 1706. He was very proud of the house and called it 'The Mansion'. His son-in-law was Edward Milward senior whose son, Edward, married Sarah Whitear, the daughter of a local rector. She outlived him and became the Countess of Waldegrave by a second marriage. She lived at The Mansion and followed a dictatorial, though benevolent, policy towards the residents of Hastings. The Revd W.C. Sayer-Milward renamed it Old Hastings House in 1892.

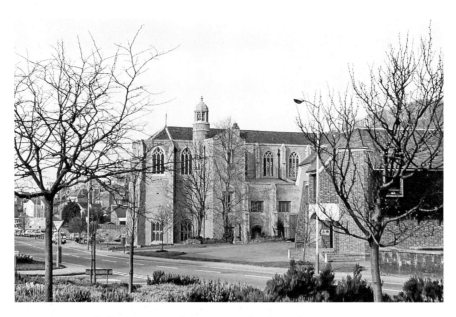

St Mary Star of the Sea, 1980. From 1875 to 1891, the writer, Coventry Patmore, lived at The Mansion as a tenant and built this Roman Catholic church in memory of his wife. The reconstructed Stables Theatre is on the right.

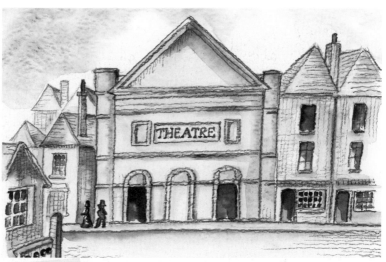

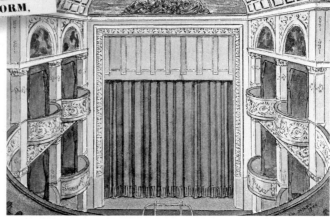

Above: **Bourne Street Theatre, 1827.** After several years of applying to the Corporation for a licence to erect a theatre, permission was finally granted in 1825 to a Mr Frederick Brooke, comedian. Despite the apparently huge effort of the Theatre Company, as evidenced by the poster left, the people of Hastings did not support it in sufficient numbers and it eventually closed. It was purchased by local Wesleyans who converted it into a chapel. The building on the extreme left is the courthouse with the stocks that is in Courthouse Street.

Above: **Bourne Street Theatre.** A contemporary playbill, 1827.

Right: **Bourne Street Theatre.** An interior view of the theatre.

The Wesleyan chapel, 2015. The chapel, built in place of the Bourne Street Theatre, has now been converted into flats.

The bottom of All Saints' Street, 1840. These houses have been restored to their Tudor appearance, so this makes a good 'then and now' subject for photographers.

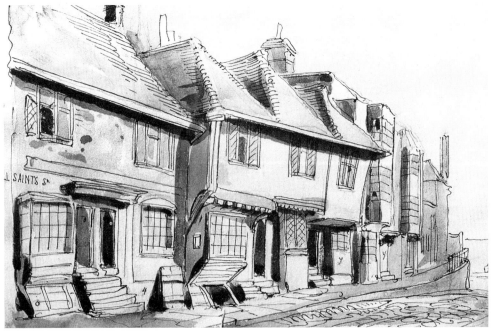

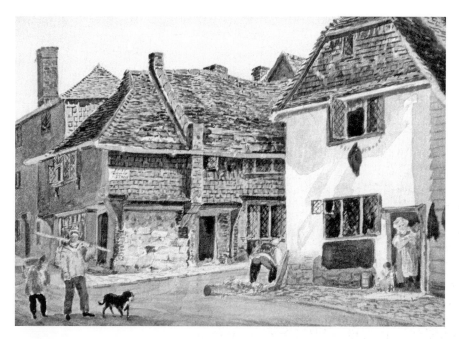

East Bourne Street, 1805. This street is not connected with the town of the same name. The location is near to the picture below on the opposite page, behind the Lord Nelson pub. The Pulpit Gate at the bottom of All Saints' Street was for pedestrians only, so wheeled traffic had to use East Bourne Street to get to All Saints' Street.

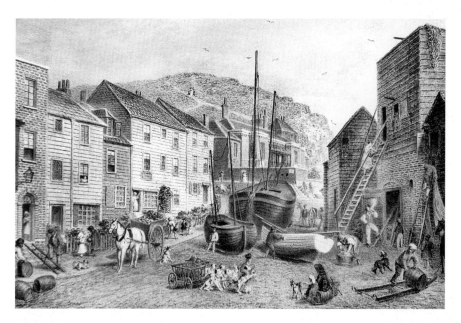

Pleasant Row, 1830. The first house, No. 2, was built in 1800, the original six being completed six years later. In 1819 the road was known as South Parade. It subsequently became Winkle Island.

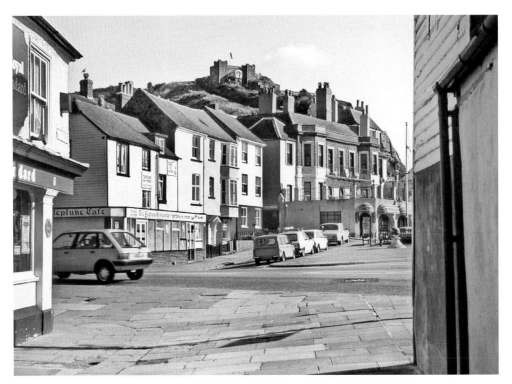

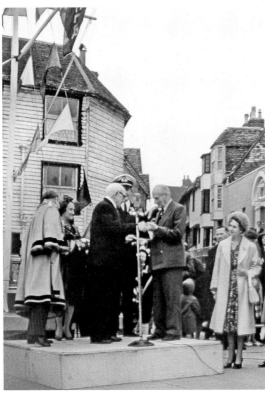

East Cliff House, on the right in the distance, 1975. This house was built in 1761 by Edward Capel, Censor of Plays, to his own design at a cost of £5,000. A later occupant was Harry Furniss, the *Punch* artist who showed the first moving pictures to be seen in Hastings. Compare to the picture of Pleasant Row on page 39.

Winkle Island, 1966. Lord Montgomery is made a member of the Winkle Club. On joining each member is presented with a winkle. When challenged to 'winkle up', any member who cannot produce their winkle must make a donation to charity. 1st Viscount Montgomery of Alamein, who was a famous Allied commander, was given a silver winkle.

3

THE SEAFRONT

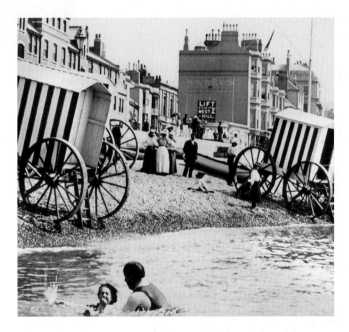

Taking a dip, 1903. The sign, which says 'Lift to the West Hill one penny', reveals to us that we are on the beach opposite Sturdee Place (which leads to George Street). The bathing machines had red and white stripes. They were owned by a private company who provided an experienced swimming instructor included in the price of hiring the bathing machine. The machine could be taken down to the water's edge whatever the state of the tide, but in later years they were used as static changing rooms at high tide. The machine is held in place by a chain attached to an iron spike driven into the beach. A horse was needed to move it.

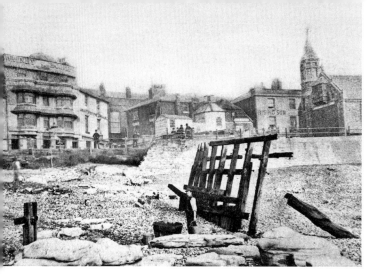

The remains of an old breakwater, now under the boating lake, 1875. The lifeboat house, demolished in 1959, is on the right. The Lower Light is visible with its lantern on top.

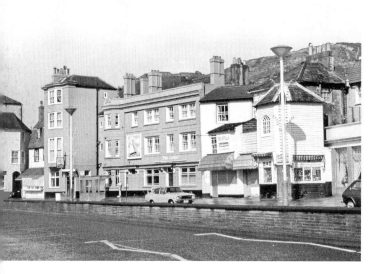

East Parade, 1963. The Lower Light, which is a gift shop in this photo, is on the right behind the lamp post. The Battery House, with the awnings at the front, is just visible between The Cutter and the houses on the left of the picture.

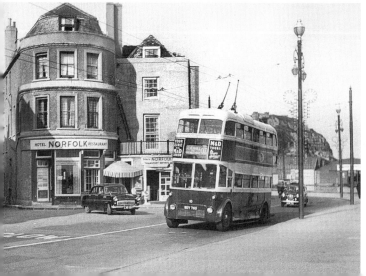

East Parade, 1959. The Norfolk Hotel and Restaurant, shown at the end of East Parade, is the location of Powell's Library. It was opened by Peter Malaperts Powell in 1813. He produced guides and maps of Hastings, but he went out of business and emigrated to America. The rival Barry's Library was opposite Sturdee Place.

Marine Parade with the beginning of East Parade on the right, 1960s. It is a warm summer's day. The man on the right has taken his coat off and the ladies are wearing summer dresses. The corner house on the right was Powell's Library, the location of which appears in the previous photograph.

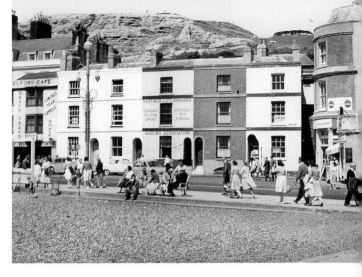

East Parade, 1959. The number 11 bus passes two ladies on its way to Hollington. The old lifeboat house is visible in the background.

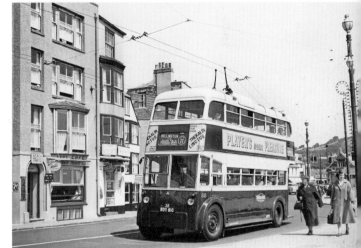

Marine Parade, 1959. This 10¼-inch gauge miniature railway was opened in 1948. The locomotive most frequently used, and therefore the most frequently photographed, was *Firefly*, shown here hauling a service to Rock-a-nore. It was built in 1936 as 0-6-0 GWR pannier tank and rebuilt in 1945 as a tender locomotive. It is now on the Kerr Miniature Railway in Scotland.

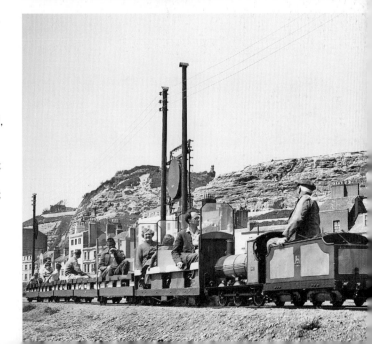

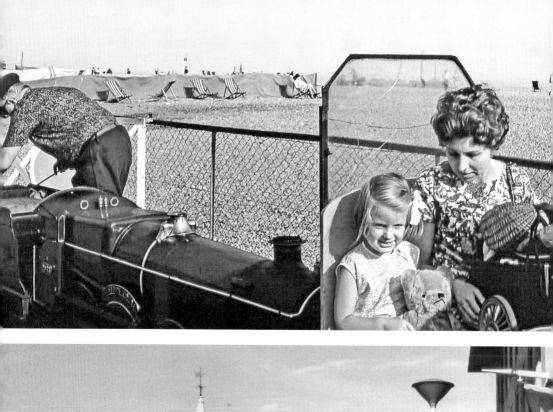

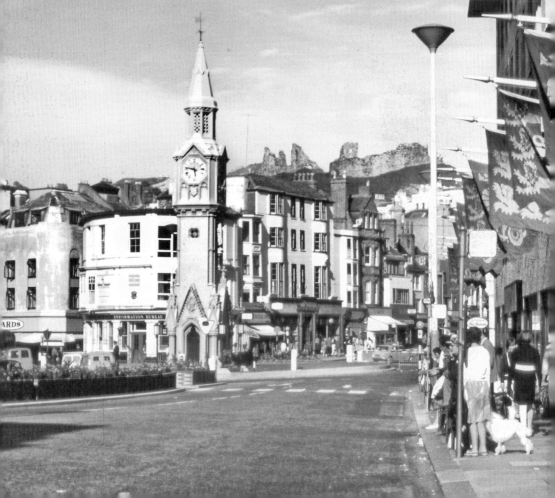

Opposite: **Marine Parade Station, 1966.** The little girl holds her teddy bear tightly as the engine driver gets ready for the steam-hauled service to Rock-a-nore. The locomotive is the *Royal Scot*, built in 1938 by Lowke as a scale model of Royal Scot Class 6100 4-6-0. It operated on the Hastings Miniature Railway from 1948 to 1975, when the railway changed hands. It was exported to the USA, but brought back in 2002 and now operates on the Royal Victoria Railway in Hampshire.

Opposite bottom: **Memorial 1066 celebrations, 1966.** The windows are all open at Wards the outfitters on the left, so it must have been a hot summer's day. The Ward's building was originally the post office until it moved to Cambridge Road. The York Hotel has been turned into an Information Bureau with the upper storey and the roof removed. The flags represent the coat of arms of Hastings, Duke William's Norman flag and King Harold's standard, which is the Dragon of Wessex, the third flag from the right in this view. Part of the Memorial is reflected in the shop window.

Below: **East Parade, 1966.** This is a view of the Battery House on East Parade, opposite the boating lake, now converted into a fish and chip shop. The battery, a sea wall with cannons on it, was built at this location by the Board of Ordnance during the Seven Years' War to deter French privateers. Sergeant Thomas Ross, RA, was the master gunner in 1806. William Green, who was one of the engineers, eloped with John Collier's daughter. The foundations of the battery were washed away by gales in 1842. It was demolished and East Parade was extended to cover the site.

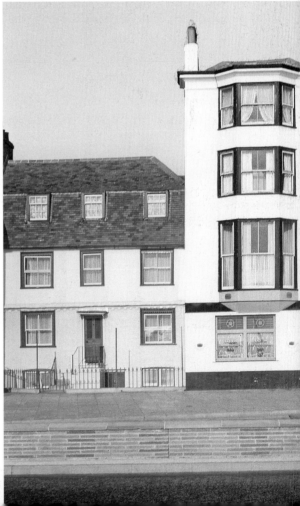

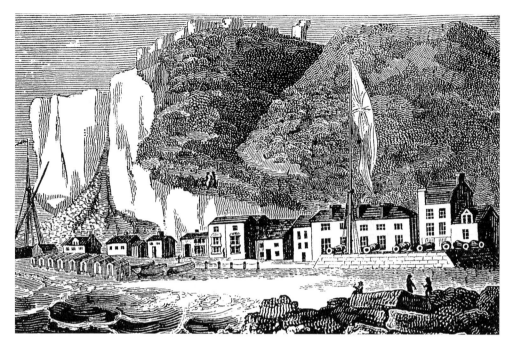

East Parade, 1862. A sketch of the Gun Battery at East Parade showing bathing machines on the left with the castle on the hill above.

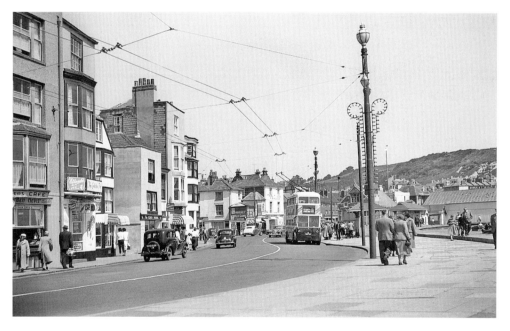

East Parade, 1959. This was originally built as a fashionable walk. The boating lake, just visible on the right, was built as a 1930s job creation scheme. It originally had motor boats, but these have now been replaced with paddle boats which do not emit fumes.

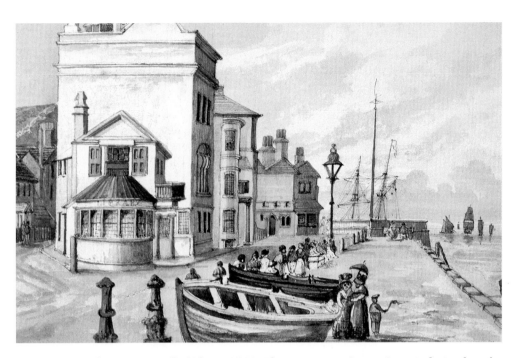

Barry's Library at Sturdee Place, 1829. The entrance to George Street is depicted on the left. The Gun Battery is on the right.

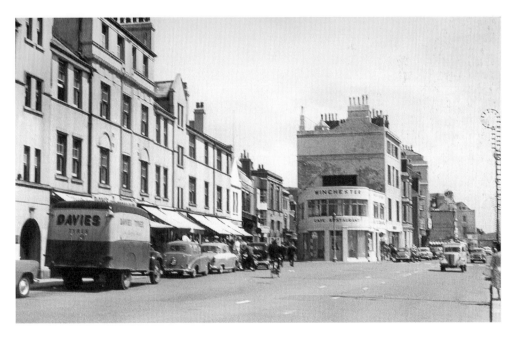

Sturdee Place, 1960. The buildings on this corner were destroyed in a huge gas explosion and resulting fire on 13 July 1963. Thirty people were hurt but nobody was killed. The location of Barry's Library above is easy to recognise once you have seen this photo.

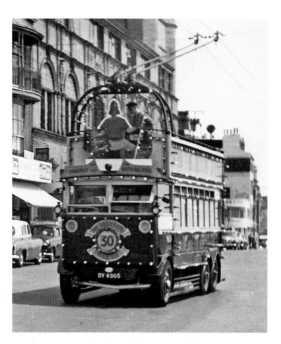

Trolley bus, 1959. *Happy Harold* is the only member of the Hastings trolley bus fleet still used in Hastings. It is brought out on special occasions. In this photograph it is under electrical operation. It was equipped with lights that would be switched on at night to add a spectacle to the seafront illuminations. It was converted to diesel when it was preserved, but the lights had to be removed because they could not be powered. The bus conductor is upstairs at the front, apparently making an adjustment to the 'Happy Harold' sign.

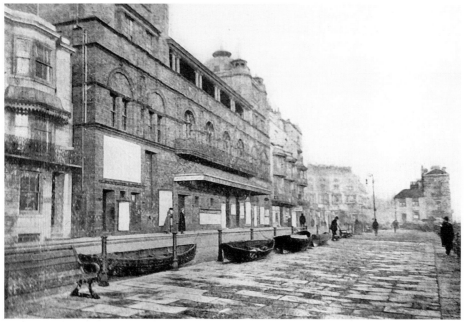

The Empire Theatre of Varieties, Marine Parade, 1904. The theatre was designed by Ernest Runtz and was officially opened on Thursday, 30 March 1899 with a special matinee given in front of the Mayor, Alderman Frederick Tuppenney JP. It changed its name to The Hippodrome in 1907 and later became the De Luxe Cinema. It presented variety shows to cinema audiences until 1947. It continued as a cinema only, then it became a bingo hall (which occasionally showed films to bingo audiences) until 1978 when it was turned into an amusement arcade and snooker hall.

Pelham Arcade, 1980. This classically proportioned crescent was designed by Joseph Kaye. He was the architect to Sir Thomas Pelham, who was made 1st Earl of Chichester in 1801. The builder was John 'Yorky' Smith. The arcade was opened in August 1825 and proved a great success. The crescent was built as a group of lodging houses, but it was obscured for many years by the Warm Baths immediately in front, which emitted black smoke. The residents agitated for the buildings to be demolished because they spoiled the view and eventually the council gave consent.

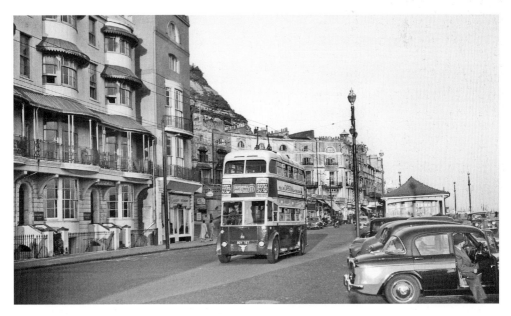

Breeds Place with Pelham Arcade in the background, 1959. On the right are visitors' cars that have been driven down for the day. The shelter and the street lamps are all gone.

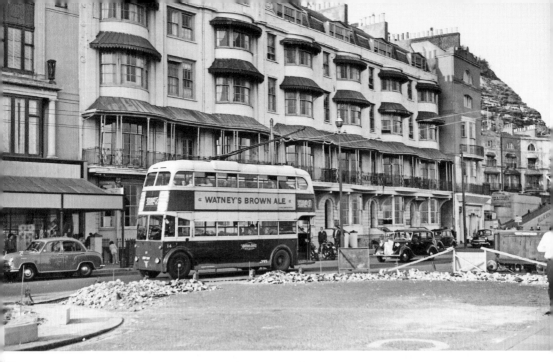

Breeds Place, 1959. James Lansdell, a builder from Battle, completed Breeds Place in 1828. He married Martha Breeds, a member of an important local family, at St Clement's in 1816. These houses, numbered 1–6 with attractive bay windows, were demolished in 1966. Mastins, seen next door on the left, was a popular department store that was demolished in 1972. The demolition of these buildings caused the seafront to lose an attractive architectural feature. In this photograph, preparations to construct the fountain are underway.

Breeds Place, 1961. Work commenced on this fountain in 1959, as can be seen in the photo above. The coaches on the right are for trips out into the countryside. The car park at this location has been substantially enlarged, once again spoiling the view for the residents of Pelham Crescent.

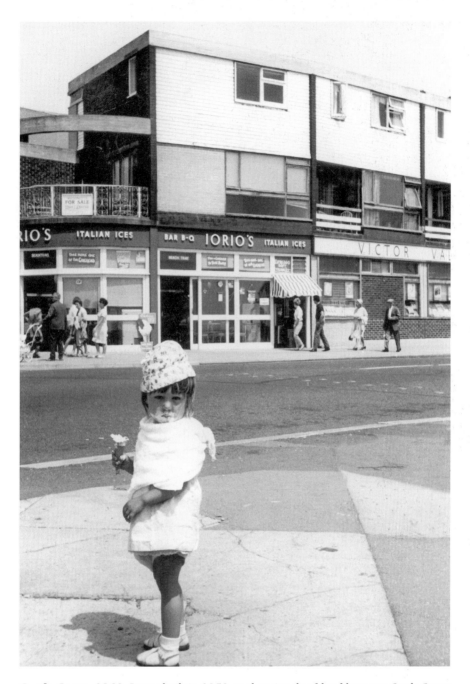

Castle Court, 1963. It was built in 1959 on the triangle of land between Castle Street and the former Caroline Place. It has a roof garden inside. Caroline Place was named after Queen Caroline, the wife of George IV. The little girl has been given an ice cream that must have come from Iorio's Italian Ices, which has now changed hands. Victor Value, which was a supermarket, can be seen on the right. It became Bejams then moved to Castle Street and now trades as Iceland.

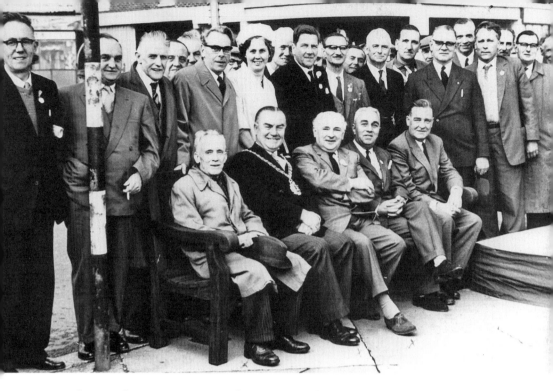

Above: **Dedicating a seat to Robert Tressell, 1965.** Fred and Jacquie Ball, who rescued the manuscript of *The Ragged Trousered Philanthropists*, are standing behind the Mayor with Hastings Trades Council in front of Castle Court on the occasion of the dedication of a seat to Robert Tressell. This is now a busy road junction.

Above right: **A classic 'then and now' view of Denmark Place, 1962.** Castle Court, shown on page 51, is on the extreme right of the picture. The 'Multigrade' oil hoarding is covering up a bombsite. These houses suffered from bomb damage, and have now been rebuilt as flats.

Right: **Carlisle Parade beach, 1903.** The parade was widened in the Sidney Little improvements in the 1930s, which means the view of the buildings in the background is now obscured. The beach was bombed in the Second World War.

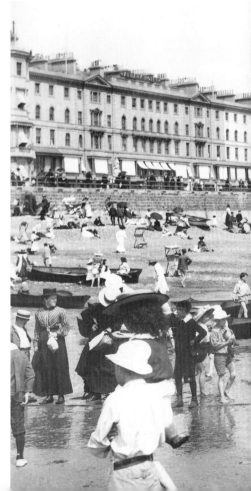

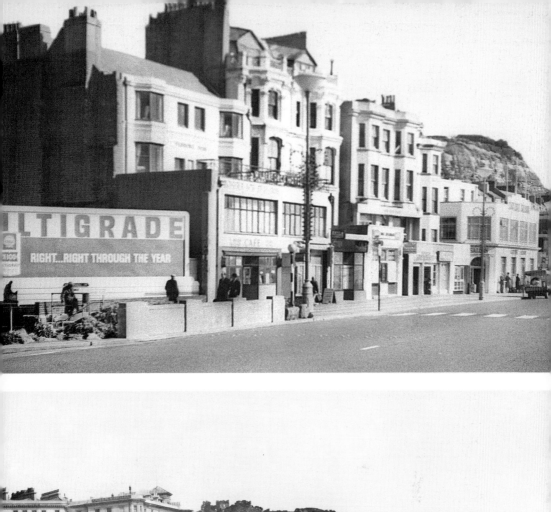

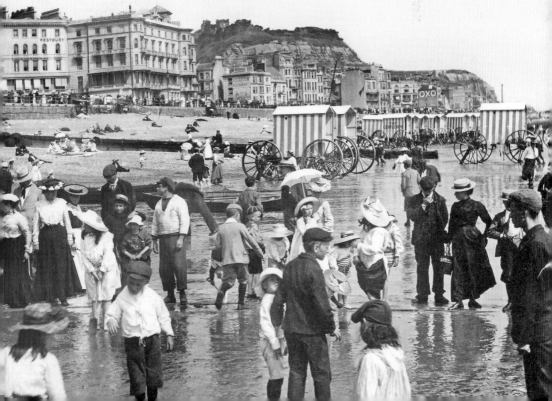

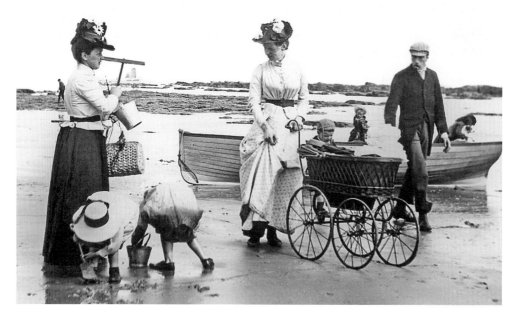

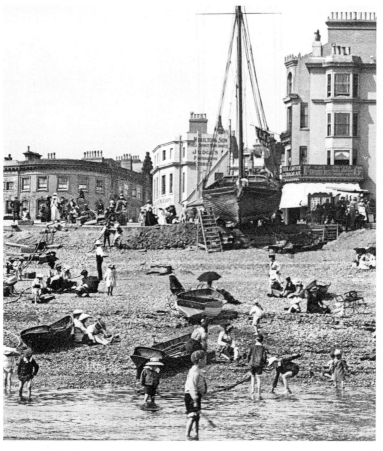

Left: **Carlisle Parade beach, 1903.** The fashions here are Edwardian. The lady on the left has purchased a net to go shrimping with her children, but they seem more interested in the bucket and spade. The lady on the right has her child in a pram which would have been hired for use on the sand.

Below left: **Harold Place from the beach, 1903.** This view is difficult to recognise because the buildings on the right were bombed. They were where the 'Multigrade' oil hoarding is shown on page x. Bank Buildings are on the left of the picture. The yacht is the *New Albertine* that provided boat trips for visitors.

Below: **The *New Albertine*, 1903.** Passengers disembarking from the *New Albertine* shown on the beach in the photograph below left. It looks a precarious operation to get off. The *New Albertine* was a replacement for the earlier *Albertine*. Boats like this operated until the 1960s when maritime safety regulations prohibited their use.

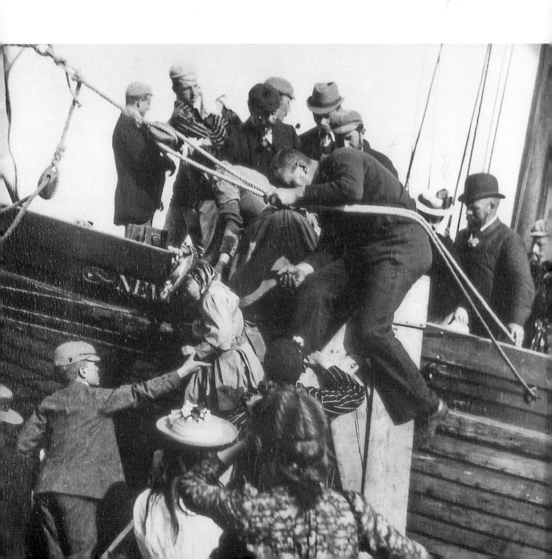

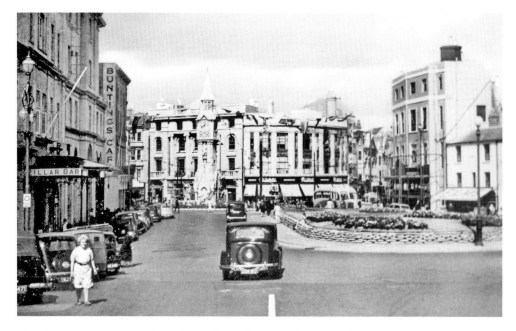

Harold Place, 1955. On the right are flower beds which had a public convenience beneath them that was always being flooded. To the left is the Pillar Bar, part of the Queen's Hotel. On the corner behind is Buntings Cafe. It is 12.40 p.m. by the memorial clock. This picture dates to after the war because of the zebra crossing, but before 1959 because of the trolley bus catenary.

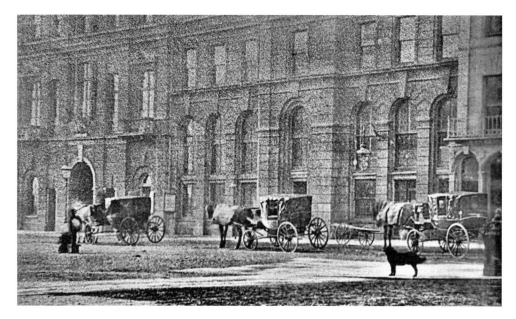

Harold Place, 1872. The original entrance to the Queen's Hotel was in Harold Place. These are horse-drawn taxis waiting for fares. The taxi rank subsequently moved to Havelock Road where it remains.

4

ROUND THE
MEMORIAL

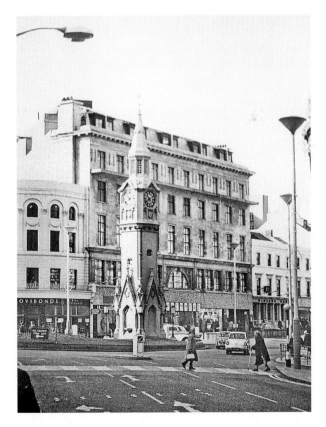

The Memorial, 1963. The Memorial was painted pink in its last years to
cover up the original stone finish that had been patched up with cement.

Priory Bridge and the Castle Rock from White Rock, 1820. This very old illustration shows what the Priory Bridge looked like from Cambridge Road.

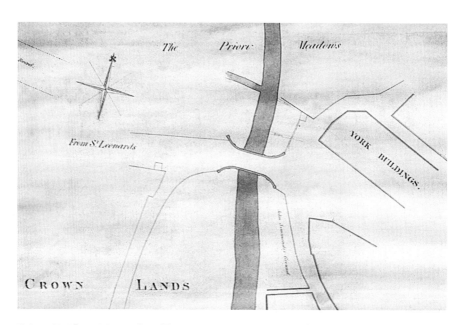

Priory Bridge, 1820. This old map shows where Priory Bridge was in relation to York Buildings, which are still standing. The bridge was the site of the Albert Memorial.

Opposite: **Prince Albert's statue, 1963.** The statue is the only part of the memorial not to have been destroyed. Work started on the memorial on 10 November 1862, but it was not completed until 1864 when the clock and dials were delivered by Thwaites & Reed of Clerkenwell. It was burned down on Saturday, 18 June 1973, and was demolished in November that year.

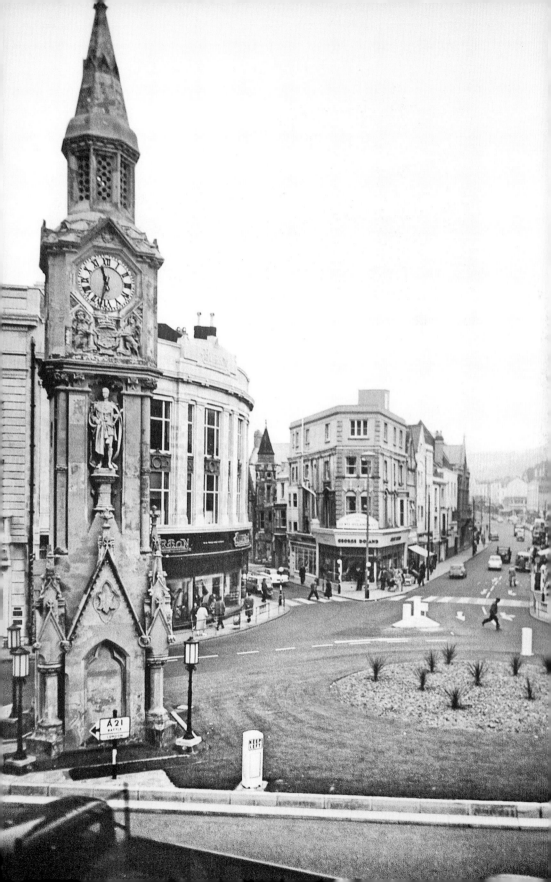

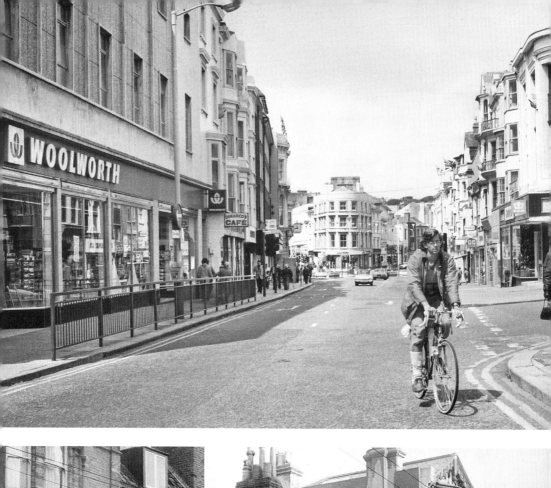

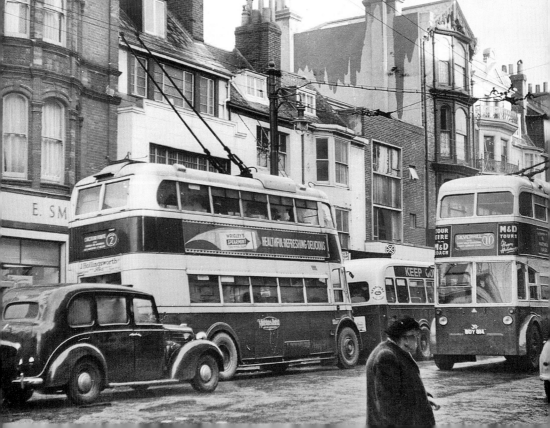

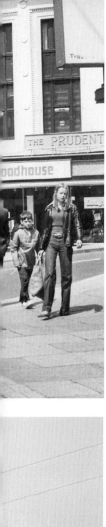

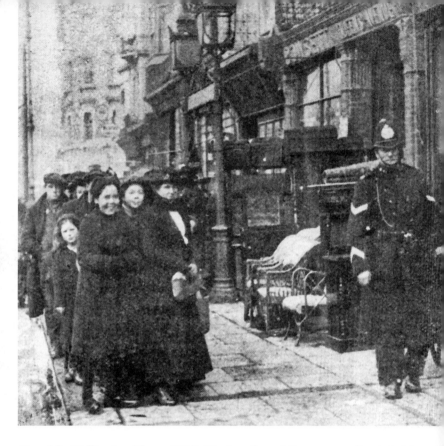

Above left: **Wellington Place, 1977.** Woolworth, on left, was a popular chain store from the United States, which came to Britain. The original owners sold it and it got into financial trouble under the new owners. Dimarco's Cafe sign is visible next door. The Woodhouse shop, on the right, sold furniture.

Left: **Wellington Place, 1959.** The trolley buses used the catenary from the old tramway system, which did not go along the seafront between Carlisle Parade and Denmark Place. This meant that the bus stops for many destinations to the Old Town, Clive Vale and Ore had to be here.

Above: **Tramway queue at York Buildings, 1907.** The lady on the left is smiling at the camera while the policeman keeps a straight face. The entrance to Queen's Avenue is where the policeman is. The tramway system was very popular. It ran until 15 May 1929 when trolley buses replaced it using the same overhead wires.

61

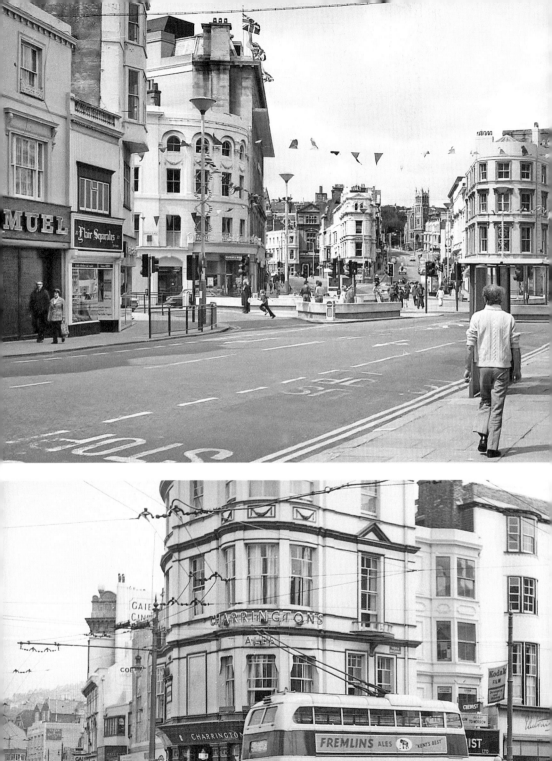
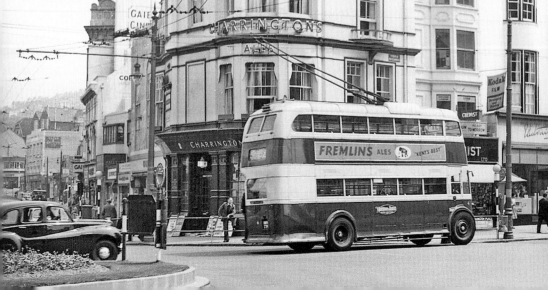

Wellington Place, 1977. York Buildings are on the right. The now demolished Central Methodist church is visible in the extreme distance on the corner of Cornwallis Gardens. The bus stop is in the same place as the tram stop shown in the picture on page 61. The bus stop was moved to Queen's Road when this street was closed to through traffic.

York Buildings, 1959. The bus stop is in the same place as the tram stop shown on the previous page. York Buildings, on the right, were built on part of Priory Meadow (then known as Priory Field), which Edward Milward inherited from his father. He sold it to William Manson for building on in 1807. These houses, which had little bay windows and tiny gardens in front of them, have now been replaced by a shop front. York Buildings were named in honour of the Duke of York who visited the town to command exercises and a review of troops between Crowhurst and Bulverhythe in 1806.

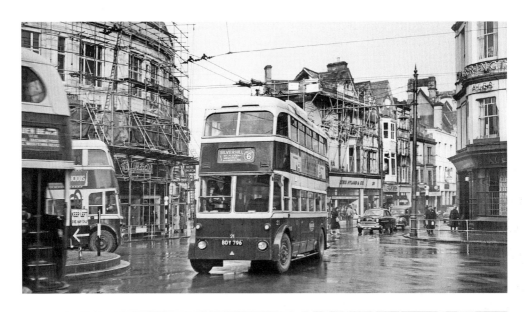

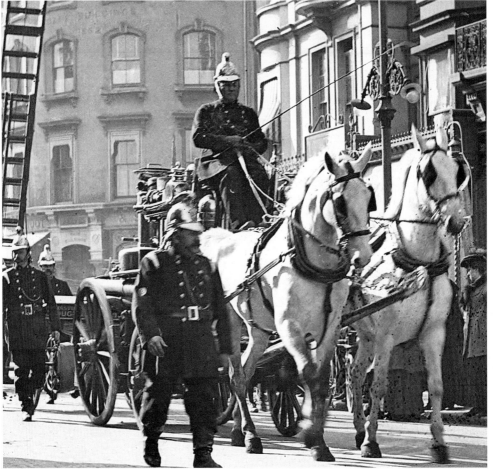

Left: **The York Hotel, on the right, 1959.** The hotel became the Information Bureau before being demolished. A shoe shop was built in its place, which is now a Costa Coffee shop.

Below left: **St Leonards Steam Fire Brigade at York Buildings, *c.*1890.** This must be before 1905 because there is no sign of the tramway system. The brigade is not attending a fire but carrying out their weekly practice. The brigade had three sections: one and two were at Hastings and the third was based at Mercatoria in St Leonards. The windows behind the ladder belong to Bank Buildings. You can just make out the lettering that says this. The facade was rebuilt by Burton's tailors when they owned it, which makes it difficult to recognise. Burton's has now been converted into a coffee shop, but part of Bank Buildings is still, appropriately, the National Westminster Bank.

Below: **The Memorial, 1960.** The trolley buses have gone, but the tramway poles have yet to be removed.

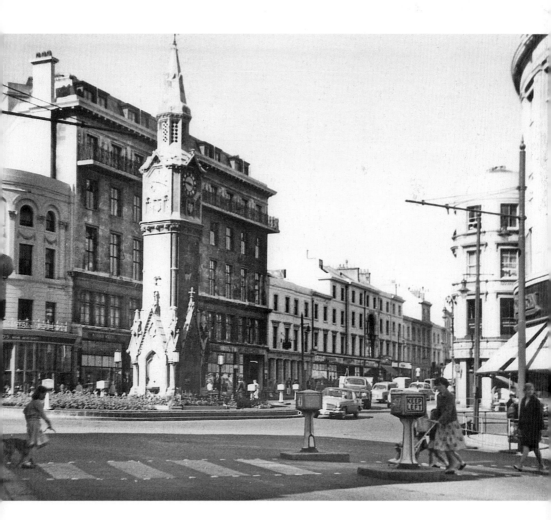

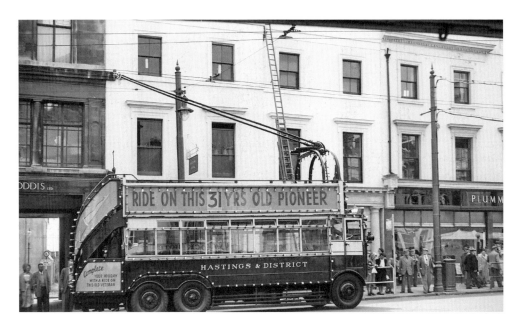

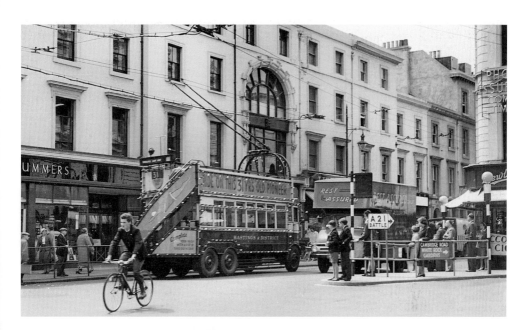

Above left: **A view before Albany Court had been built, 1959.** On the left, there is a way through to the seafront. Plummer Roddis was subsequently bought out by Debenhams and it still trades under this name. *Happy Harold* operated along the seafront from a special bus stop and is on its way to pick up passengers.

Left: **Christmas, 1959.** An Austin and a Morris Minor, together with the trolley bus, mean we cannot mistake the time period. The single-decker on the left is an East Kent bus that is going to Falaise Road where the driver would take a break.

Above: ***Happy Harold* progresses up Robertson Street, 1959.** The shop on the corner is a tobacconist which is now a newsagent and sweet shop.

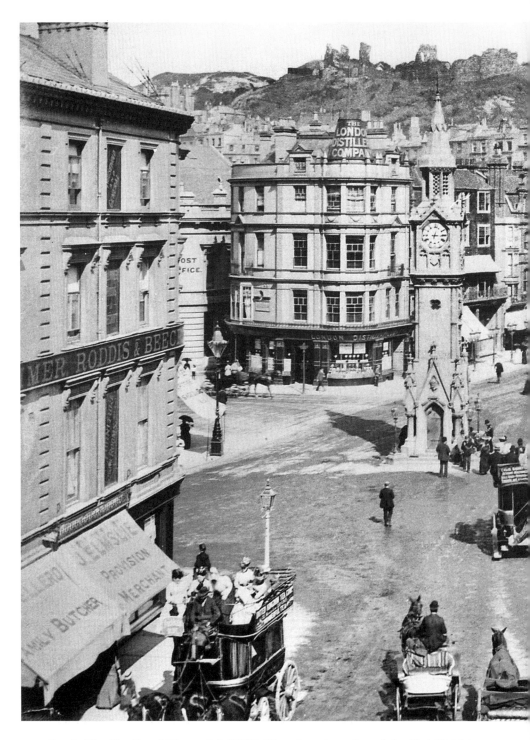

Cambridge Road and Memorial, 1895. There is a clear view of the York Hotel in the centre. If you compare this to the photo on page 65, you can see the department store on the right had the facade rebuilt.

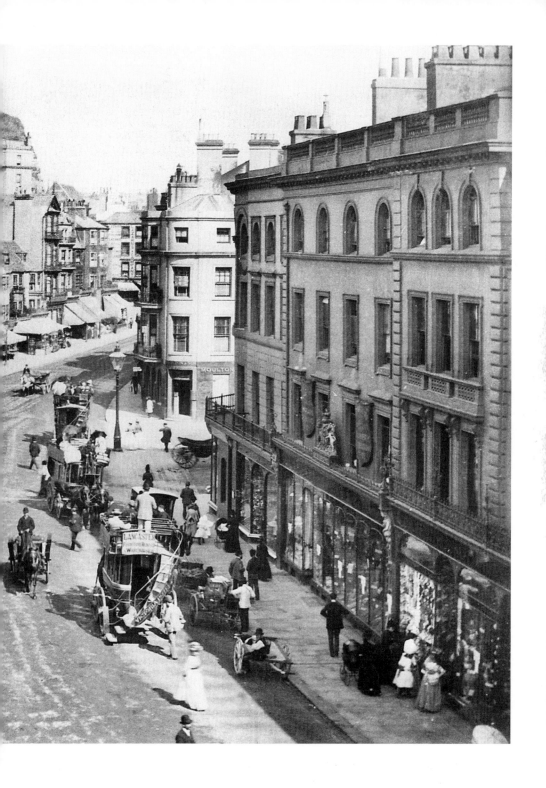

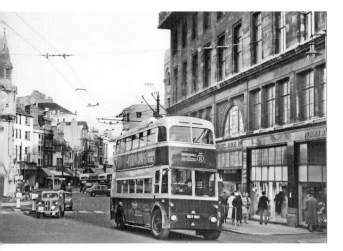

Plummer Roddis, 1959.
The department store on the right traded for many years as Plummer Roddis, then as Plummers before being taken over by Debenhams. This lucrative town centre shop has three entrances, two in Robertson Street, and one on the seafront, deliberately arranged so customers can enter by one entrance and leave by another, buying goods along the way. It always profits from wet and windy weather, which drives customers inside.

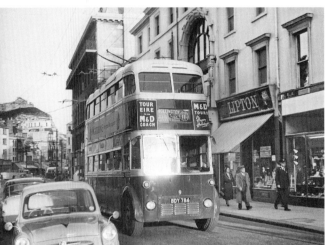

Jepson's, 1959. It is 6.45 p.m. outside Jepson's and the evening sun is reflecting brightly off the bus driver's window. Jepson's started out as a toyshop in Norman Road before moving to this shop. It sold clothes, fancy goods and stationery, but kept a marvellous toy department on the top floor, which had a Hornby Dublo dealer's demonstration layout.

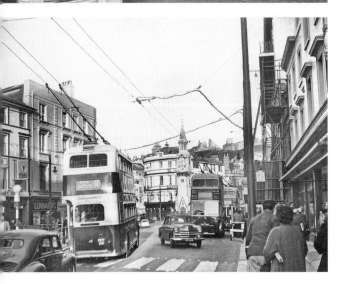

Robertson Street, 1959.
This street was a through route for buses because the overhead wires did not go along Carlisle Parade, which was only widened in the 1930s after the wires were installed.

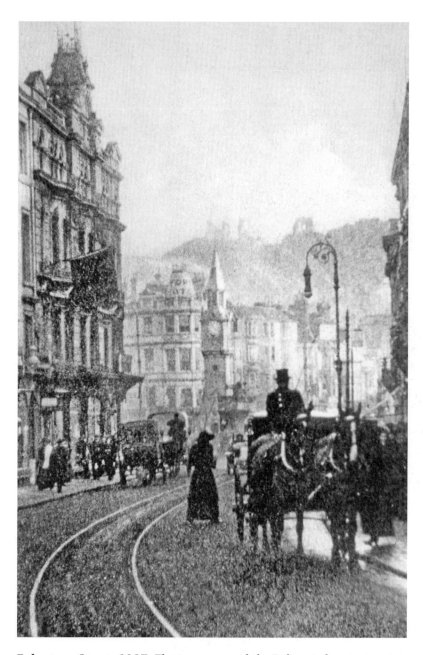

Robertson Street, 1907. The tramway used the Dolter stud contact system along the seafront as far as the Memorial, which is why there are no overhead wires in Robertson Street at this time. The Dolter system was replaced by petrol electric trams in 1914, but overhead electrification was extended to this section in 1921. Tramway companies were not allowed to use the Dolter stud system after this time and were restricted to running off overhead wires.

A tram is just visible in the background, but it is mainly horse-drawn traffic in this view. The horse and carriage on the right would have belonged to a local hotel.

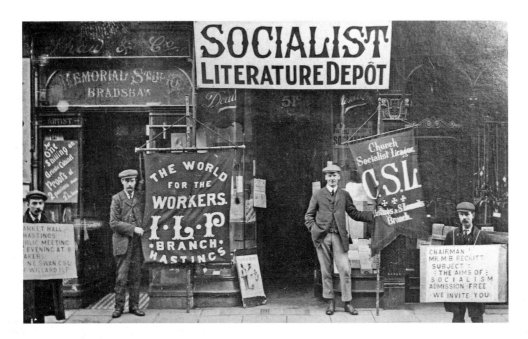

Above: **Number 51c Robertson Street, 1910.** At this time being a Socialist was considered an essential part of being a Christian. The man on the left is advertising the recently formed Independent Labour Party whilst the other man is promoting the Church Socialist League. A marvellous 'then and now' picture, of which there are many in Robertson Street, a favourite photographer's haunt.

Opposite top: **Robertson Street, 1989.**

Opposite bottom: **The Congregational Church, 1875.**

Taken from the same viewpoint, these two photographs show the changes made over time, although the underlying architecture remains. The tobacconist has become a travel agent and the fishmonger has become a pizza parlour. The Congregational Church, in the corner, has undergone significant alteration and is now the United Reformed Church. Today the shopfronts have been fully modernised with rebuilding to the left of Perfect Pizza being transformed into the Creative Media Centre.

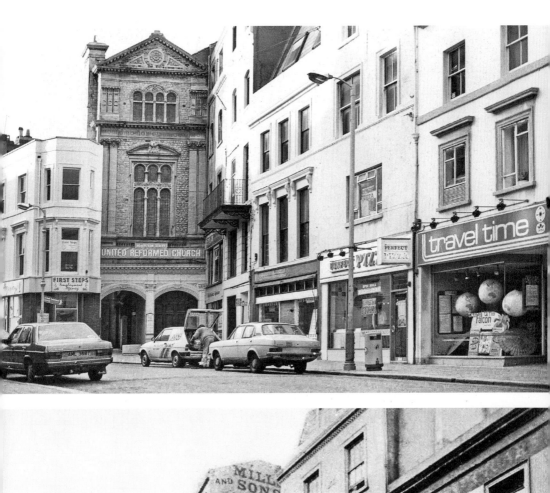

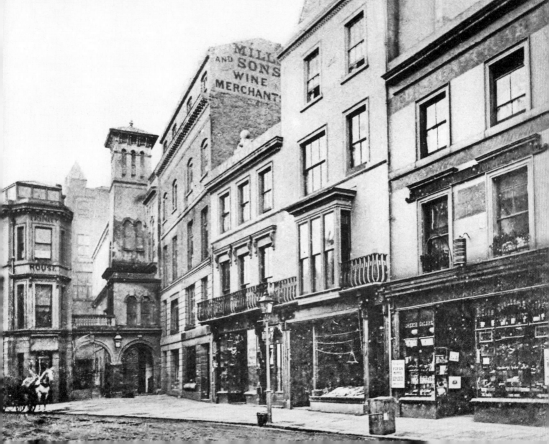

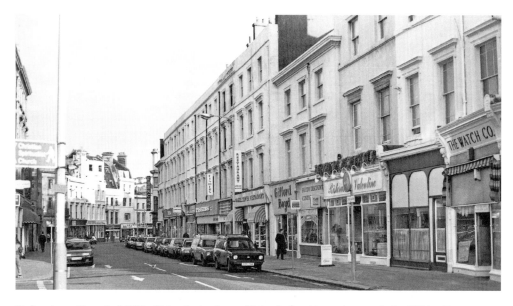

Robertson Street, 1989. This photo shows Fisher's furniture shop and the White Tower restaurant in the distance. Gifford Boyd was a photography shop which traded for many years. Next door is a restaurant and on the extreme right is the Watch Company which mainly sold clocks, but also stocked watches and jewellery. All of these shops are now gone, which makes this an interesting picture.

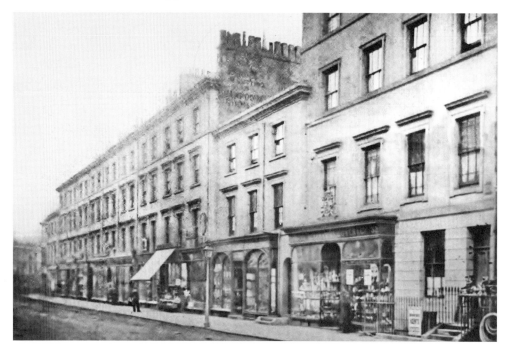

Robertson Street, 1872. This photograph is taken from the same perspective as the view above. It reveals how Robertson Street was originally built as a parade of shops with accommodation above.

5

QUEEN'S ROAD, ALEXANDRA PARK, MOUNT PLEASANT AND ORE

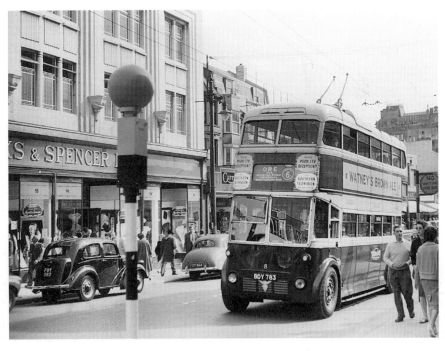

Queen's Road, 1959. Marks & Spencer has now moved across the road to Priory Meadow Shopping Centre. There is now a pelican crossing where the zebra crossing used to be.

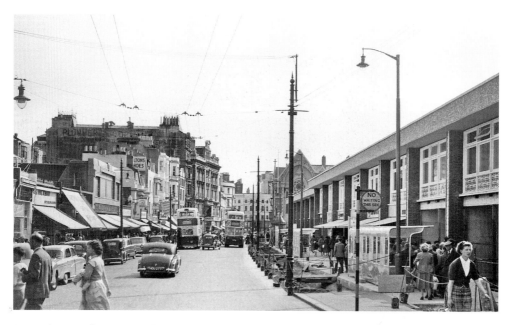

Queen's Parade, 1959. This is the last year of operation for the trolley buses and the catenary poles were then removed and the road widened. In the circular logic of road schemes, this modification was reversed when the Priory Meadow Shopping Centre was built.

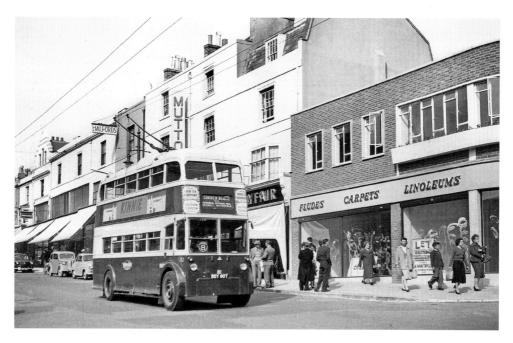

Queen's Road, 1959. The Fludes carpet shop on the corner subsequently moved to Silverhill, where it remains. The shops in Queen's Road all have their blinds down to protect window displays from the hot sun, a practice that you seldom see nowadays.

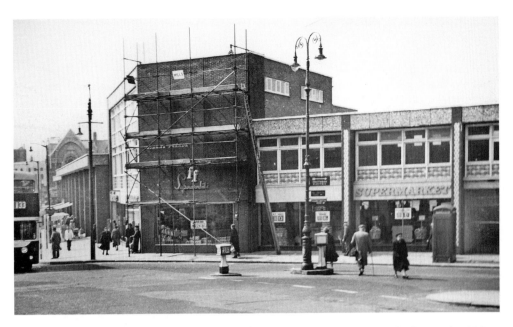

The corner of Waldegrave Street and Queen's Parade, 1962. The bus is the 133 to the King's Head, which was the number 11 trolley bus route. The Fine Fare supermarket became a Marley's DIY store before being demolished.

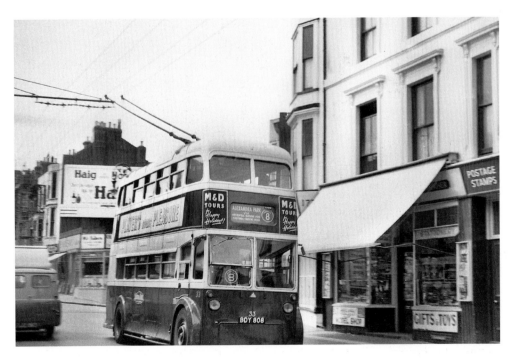

Queen's Road, 1959. The side street leading to St Andrew's Square behind the trolley bus is easily recognisable. The toyshop on the right became a hairdresser's.

Queen's Road with St Andrew's church, 1885. The horse-drawn bus dates this photograph to before 1905 when the tramway opened, and to after 1883 when the Grammar School, visible in the background, was built.

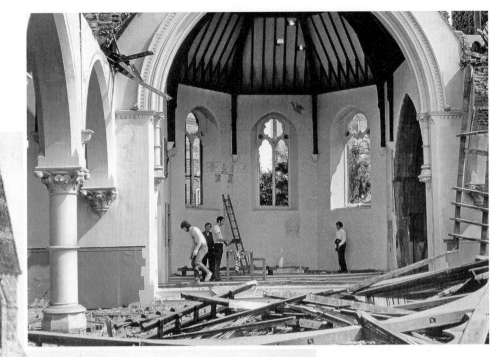

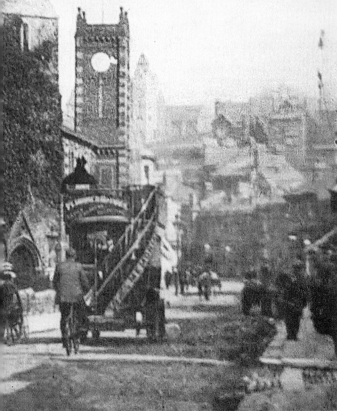

Demolition of St Andrew's church, 1970. The volunteers who tried to save the mural, painted by Bob Noonan, also known as Robert Tressell of *The Ragged Trousered Philanthropists*, were threatened with eviction for having no insurance, so only one small piece could be saved.

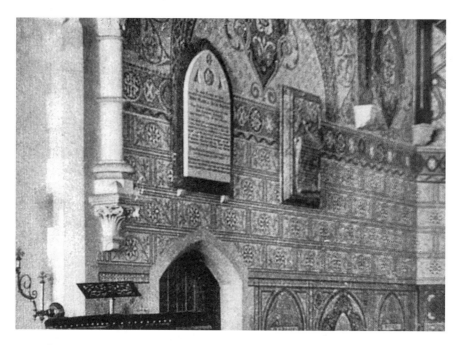

St Andrew's church, 1950. This image shows a section of mural which is now in Hastings Museum.

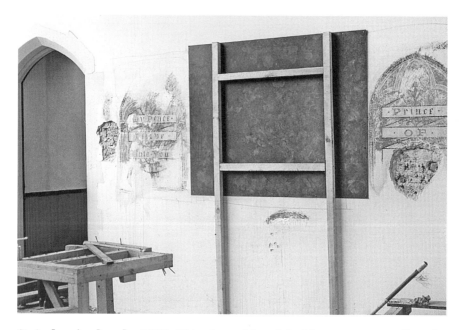

St Andrew's church, 1970. This piece of board had been put up to allow the surrounding wall to be demolished, leaving the section to be saved intact. The paint has been scratched away on the left to read 'My Peace I give Unto You' and on the right it says 'Prince of Peace'.

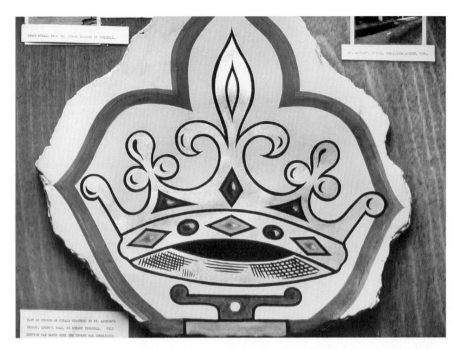

St Andrew's church, 1970. A small piece of the mural that was restored by Fred Bus, a local sign writer who trained at Hastings School of Art and worked for Hastings Corporation.

St Andrew's church, 1970. The section of mural as it was recovered from the church. It was restored following a public appeal. The church was located at what is now the Morrison's supermarket petrol station near the top of Queen's Road.

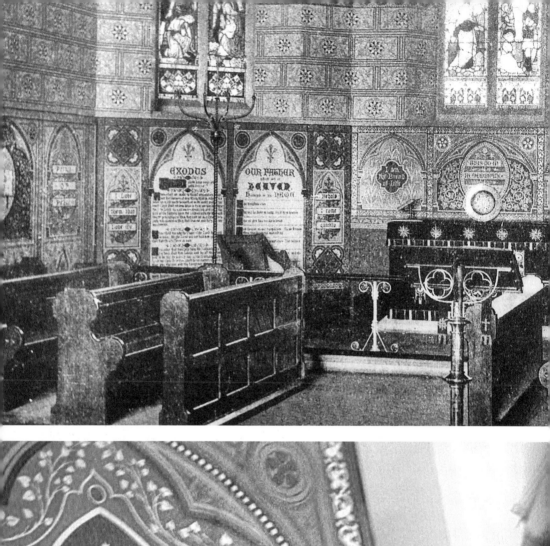

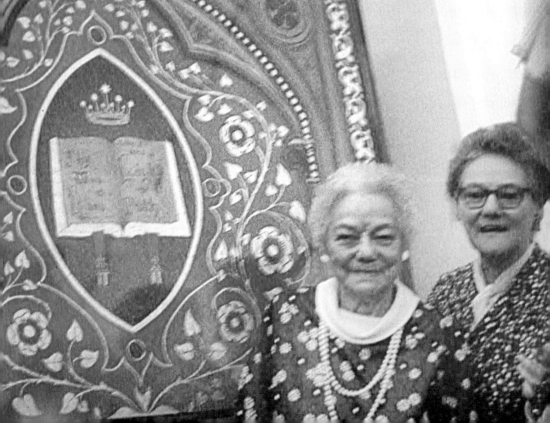

First edition published in 1914. In those days typesetting had to be done by hand and it would have been too expensive to print a full version, so an abridged version was released. Fred Ball bought the manuscript from the original publisher and when he discovered it had been abridged, he decided to have it published in full. Kathleen said she thought he was right to do this as the full version gives a much better explanation.

Opposite top: **St Andrew's church, 1950.** The restored section of the mural is on the extreme left. Bob Noonan was a committed Christian who worshipped at this church and that is how he got the commission for the mural for his firm, Burton and Co.

Opposite bottom: **Kathleen Noonan-Lynne and her daughter, Joan Johnson, pose in front of the restored mural in Hastings Museum, 1982.** She made her father Bob Noonan posthumously famous by publishing a novel about working men's lives in Hastings. When she heard that the council had named a street 'Robert Tressell Close', she wrote, 'Oh, how Dad would have laughed!'

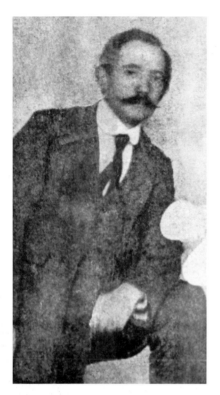

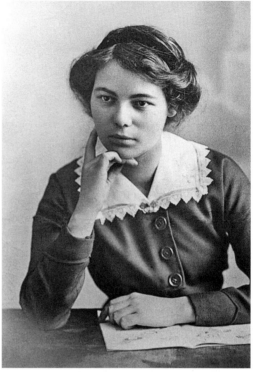

Bob Noonan, 1910. The author of
The Ragged Trousered Philanthropists.

Kathleen Noonan, 1913. Daughter of Bob
Noonan.

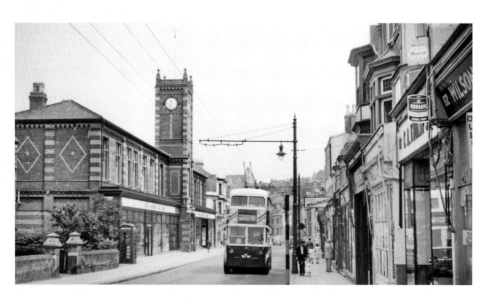

Queen's Road, 1959. The entrance to St Andrew's church is on the left with the now
demolished gas showroom building. The old grammar school in Nelson Road can be seen
in the distance.

Watermill House from an old watercolour painting, 1810. The mill was situated on the priory stream in Waterworks Road, which now leads to Morrison's supermarket. It was pulled down in 1830.

St Mary's Road, 1957. A small quantity of paper had caught fire in the wholesale distributors and it has caused much excitement with two fire engines on the scene. The Fire Station was in Priory Road so the brigade arrived quickly. The Mount Pleasant tunnel is on the left behind the houses.

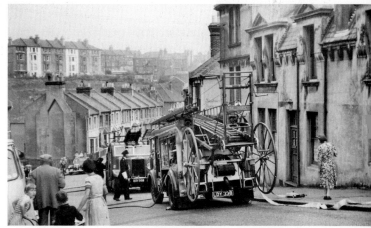

St Mary's Road, 1957. The 'Wholesale Distributors' in the picture were stationery suppliers. Our photographer, who was a boy at the nearby grammar school, had been on the nearby footbridge photographing trains when this incident occurred, so hence these pictures. There is hardly any smoke and nobody was hurt in the incident.

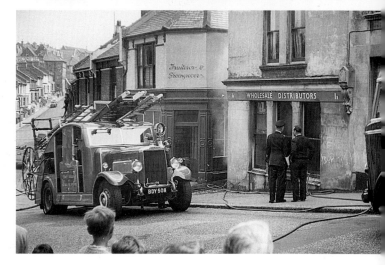

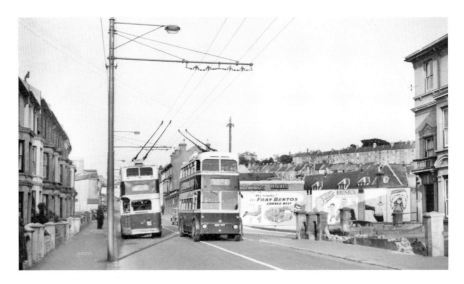

Mount Pleasant School, 1959. This view is difficult to recognise, unless you went to school here. On the right, behind the hoarding, is the roof of Mount Pleasant School. Pupils used to gather on the corner where the bus is. The school building that you can see was the junior school, the infants' school is out of sight. The headmistress at this time was Miss Draper, who older readers may remember.

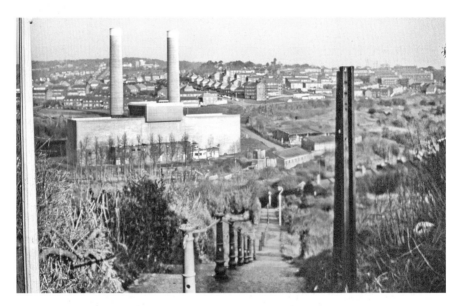

Broomgrove Power Station seen from Priory Road, 1970. This oil-fired station had two 63-megawatt generators. It replaced the previous coal-fired station. Fuel was brought by rail and delivered to the siding, which ran alongside the power station. To the lower right of the power station is Alsford's timber mill, now used as a children's play area. Now demolished, the block of flats on the corner of Chiltern Drive and Upper Broomgrove Road is also visible here. These steps were the way home from school for boys from Priory Road School. They have now been rebuilt on a different alignment.

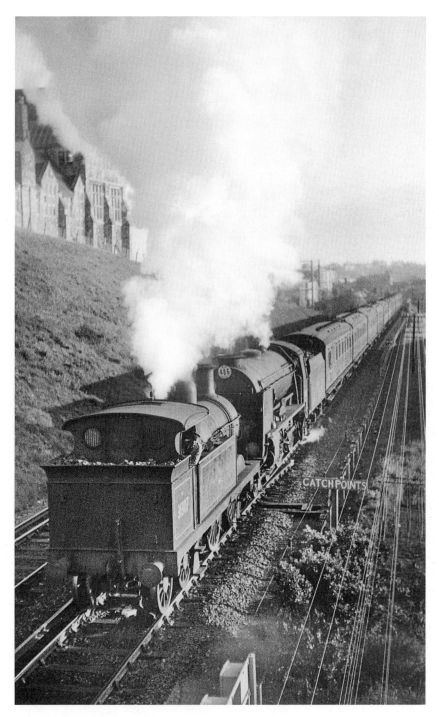

From the footbridge, 1957. This SECR Class H is double heading a Schools Class with an excursion train that is passing the old grammar school in Nelson Road on the left. The footbridge from which this photo was taken is between St Mary's Road and St James's Road. The gas works can be seen faintly in the background.

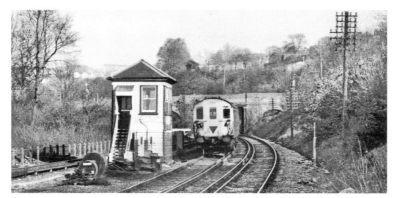

Above: **Ore Station signal box, 1976.** This is a class 416 2EPB waiting by the signal box for the points to be changed for the return journey to Brighton. This signal box is unusual in that it has sash windows instead of sliding windows. Its functions were transferred to Hastings in 1977.

Opposite top: **Ore Station, 1976.** The station was always kept staffed to provide facilities for drivers and cleaners using the carriage shed on the right. When the facilities here were moved to West Marina, the station was left unstaffed and a vandal burnt it down.

Right: **Mount Pleasant Tunnel viewed from the footbridge to St James's Road and St Mary's Road, 1957.** A double-headed steam excursion train is making the climb to Ore, while an Electric Multiple Unit passes on the other line.

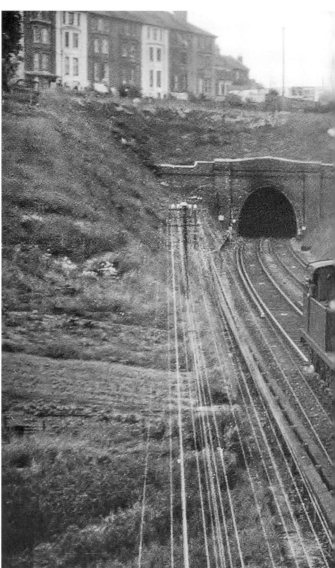

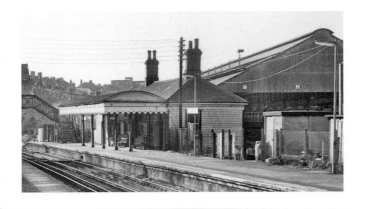

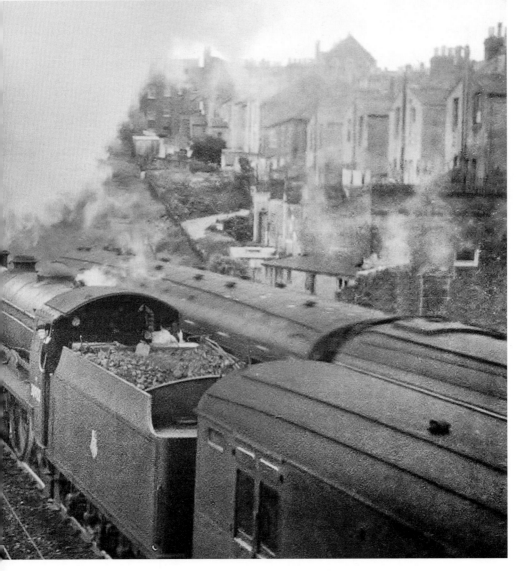

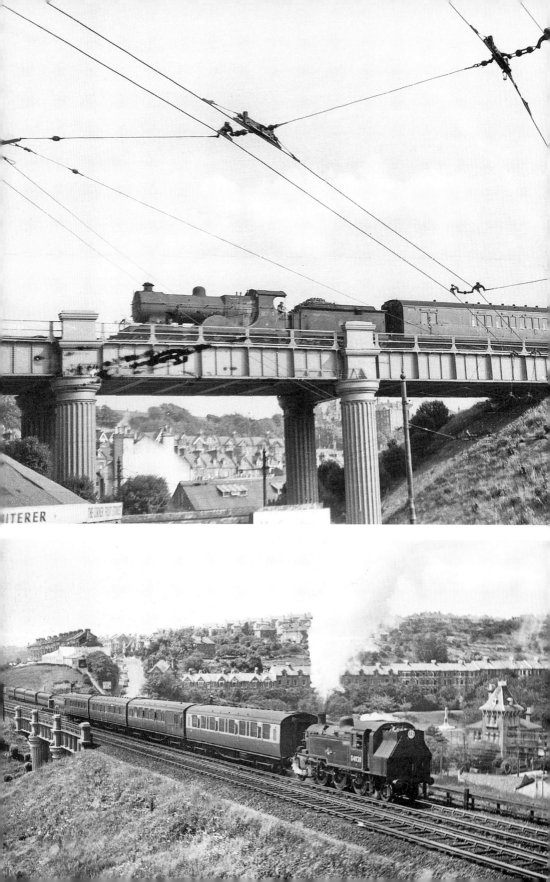

Left: **This must surely be a Rye and Ashford service, 1957.** This bridge replaced the earlier St Andrew's Arch. It is known as Queen's Road Bridge when it is seen from the point of view of the road and St Andrew's Bridge from the point of view of the railway. So in this instance, it is St Andrew's Bridge.

Opposite bottom: **A Rye and Ashford Service, 1957.** Alexandra Park and Lower Park Road can be seen in the background with Braybrooke Road steeply climbing the hill on the left.

Below: **Schools Class 30923 *Bradfield*, 1957.** Seen here hauling an empty coal train to Ore where coal would be loaded and taken to West Marina. The rear of St James's Road and the bottom of Elphinstone Road are visible on the left. The trees behind the houses are in Alexandra Park.

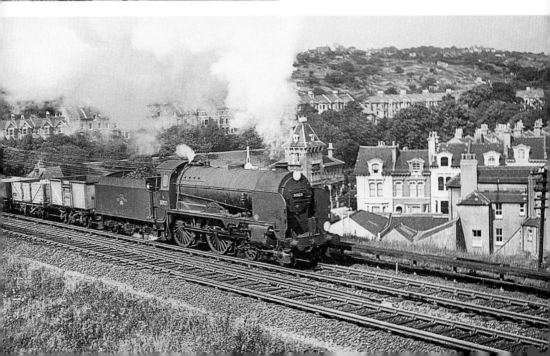

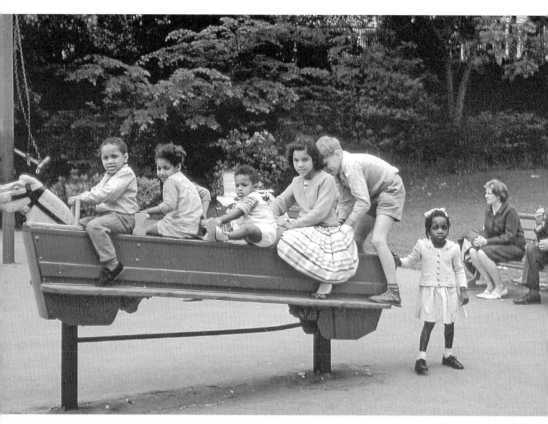

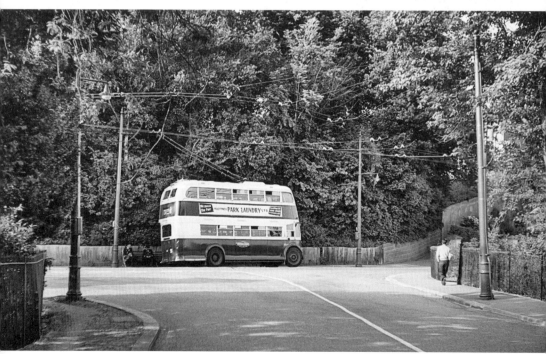

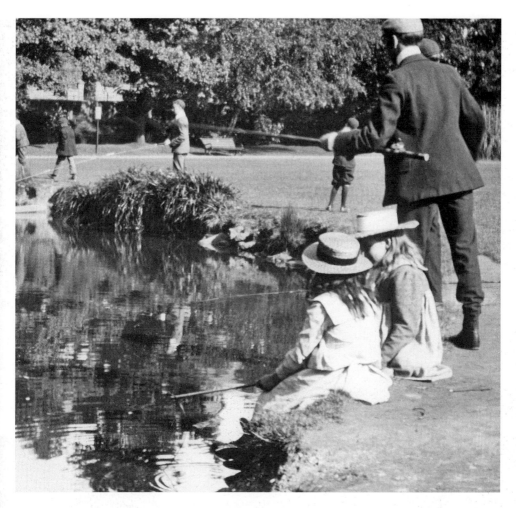

Opposite top: **Children's Corner, Alexandra Park, 1966.** Many older residents of the town will remember this rocking horse, which is not now permitted under health and safety regulations.

Opposite bottom: **Park Cross Road, 1959.** Now renamed Dordrecht Way after a 'twin town' of Hastings, two large blocks of flats have been built in the woodland behind the bus. There is often an ice-cream van on this corner along with many parked cars to spoil the view.

Above: **Girls fishing at the pond in Alexandra Park, 1910.** In 1860 the Water Committee of the Board of Health bought a lease from the Countess of Waldegrave. The reservoirs were cleaned and opened to the public in 1864 as St Andrew's Pleasure Gardens, being in that parish. The pond nearest the entrance to the Park Gates was called Shirley's Pond after a previous tenant. It was the boating lake for many years. It has now been made back into a pond for wildlife. The Shorden and Newgate woods were added later and the whole area was opened as Alexandra Park by the then Prince of Wales (later Edward VII) on 26 June 1882. The park was designed by Robert Marnock, who was a distinguished Victorian horticulturalist. His ideas were to balance 'the sublime and the beautiful'. This involved using curves in preference to straight lines and keeping the park as natural as possible.

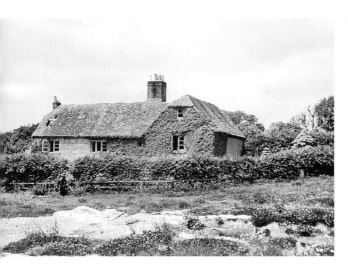

Old Roar Farmhouse, 1963. This seventeenth-century farmhouse was surrounded by a beech hedge and was known as Hickman's Farm. Its original name was Hull's Farm. It was subsequently owned by Edward Chapman, who was born on the farm in 1810. The Chapmans had a dairy at Gensing Road.

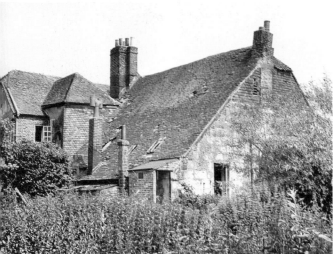

A close-up of Old Roar Farmhouse, 1963. This farmhouse was a listed building under the Town and Country Planning Act, 1962. It was allowed to become derelict and the council approved its demolition in May 1963.

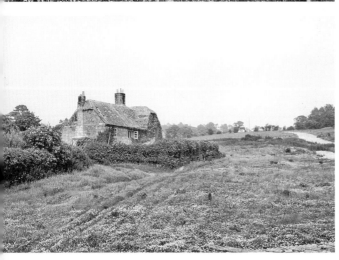

Old Roar Farmhouse, July 1963. The house was in very good condition when it was abandoned, but it was allowed to go to wrack and ruin. It was a fine example of a seventeenth-century yeoman's home. There is now a modern housing estate on the site and no trace remains, which makes this a tragic 'then and now' picture at TQ 805518 near Hickman Way, marked Hull's Farm on OS Map 1890–1920.

Old Roar Gill waterfall from which the farm takes its name, 1820. It was originally privately owned, but was opened to the general public in 1933. The waterfall was initially fed from a reservoir and a sluice was opened to entertain visitors who had paid to see it. In those days it was fashionable to create a 'sublime' sight artificially, but make it look as natural as possible.

A metal bridge, which is neither sublime nor beautiful, has been erected across the top of this waterfall and you can cross it on your way to the housing estate to take a 'now' photograph of Old Roar Farm.

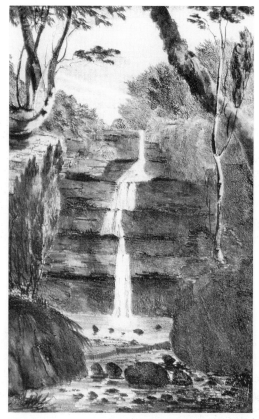

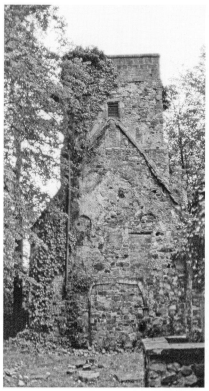

The tower of the parish church of St Helen before it was restored, 1978. This church had a long history and, before it was restored, it had a distinctly spooky aspect. It was left as a ruin on purpose because the graveyard, being consecrated ground outside the town, was still needed. The graves of smugglers and criminals who were not thought fit to buried in the town were laid to rest here.

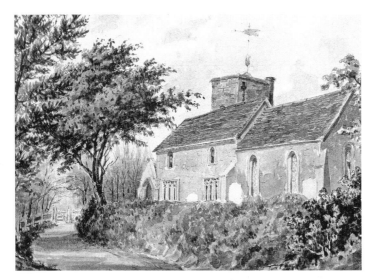

The parish church of St Helen, now a ruin, 1815. The history of this church has been written by the late Canon F.W.B. Bullock who tells us of its Saxon beginnings.

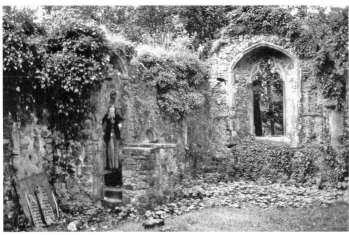

St Helen's church before restoration, 1978. The church is difficult to find, so makes a perfect 'unseen' view. Hollington Church-in-the-Wood was originally similar, but that has been extensively modernised.

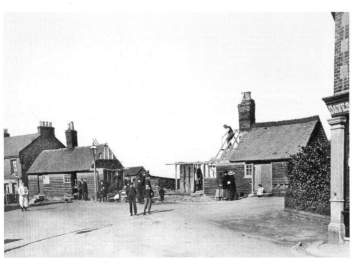

Although it is difficult to guess where this is, it is Dawes Corner at the junction of Priory Road and Frederick Road, 1903. The barracks and Dawes Drugs Stores are being demolished to make way for improvements at this junction in readiness for the new tramway system.

Halton Barracks, 1903. We are looking north from Priory Road towards Frederick Road. This is now a busy road junction. Halton had a long military history – it belonged to the Manor of Rameslie before 1066, and, after the Conquest, it merged with the Manor of Brede as witnessed on a deed by William de Haltune shortly after 1200.

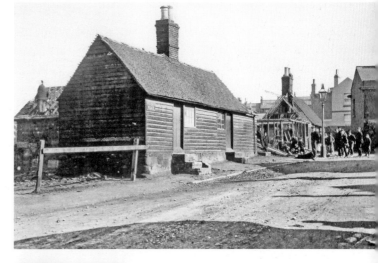

The corner of Egremont Place and Halton Terrace. This corner, at the end of Bembrook Road, was known at that time as the corner of North and South Terrace. It is still recognisable, but has been substantially altered.

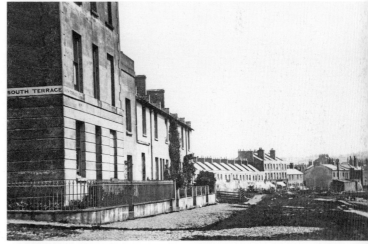

Malvern Way, 1976. This is how the Broomgrove Estate looked shortly after it was built. The maisonettes in The Cheviots and Cotswold Close have now been demolished. The TV documentary about Fred Ball, who saved the manuscript of *The Ragged Trousered Philanthropists*, was made here.

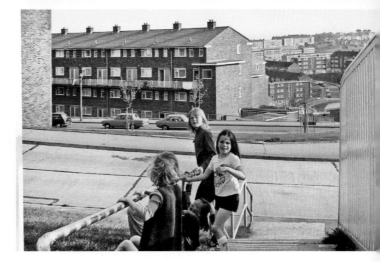

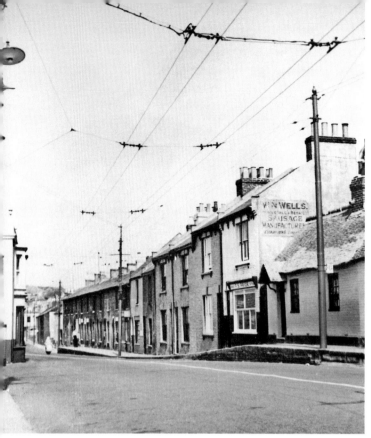

Priory Road at The Fortune of War, 1950. This pub originally opened in 1810, but had to be rebuilt thirty years later due to poor construction methods. This picture has to be before 1959 when the trolleybus wires were removed.

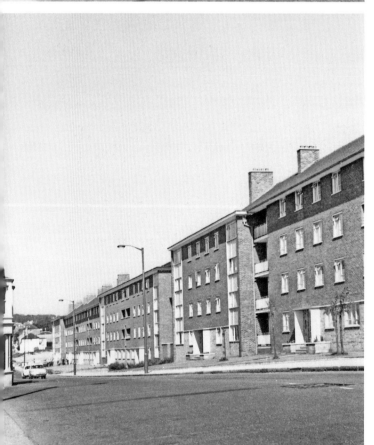

Halton Flats, 1963. Building commenced on 24 June 1961. The flats have now been refurbished with larger balconies. The Fortune of War can be seen on the extreme left in this picture, which proves it is the same place. The pub closed in 1969 and was demolished in 1970 to widen the road. The license was transferred to a brand new pub on the Broomgrove Estate, which was to be called The New Fortune, but they decided to call it the The New Broom instead. That name did not last either. It was The Malvern from 1971 and closed in 2008.

6

WHITE ROCK AND ENVIRONS

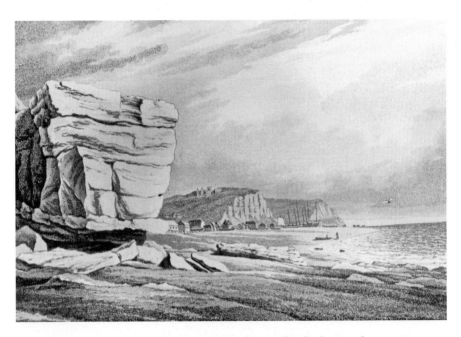

The White Rock in 1816. The impressive white rock, which gives the area its name, was composed of white sand and not of chalk as is commonly supposed. There is no chalk at all in the Hastings area. The nearest exposed chalk is at Beachy Head which is 20 miles away at Eastbourne.

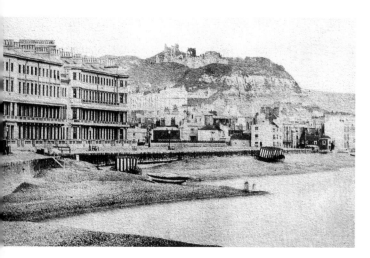

Carlisle Parade, 1857. This picture shows the parade before Robertson Terrace and the Queen's Hotel were built. The parade as it was originally built was much narrower.

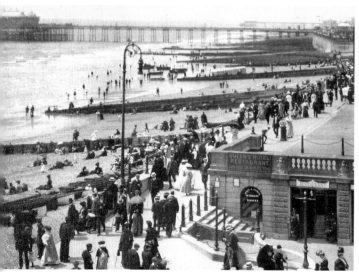

Carlisle Parade from the corner of Harold Place, 1900. This view explains why trams could not go along the seafront at this point. Until the parade was widened, it was very easy for rough seas to wash into Harold Place and the area around the memorial was often flooded.

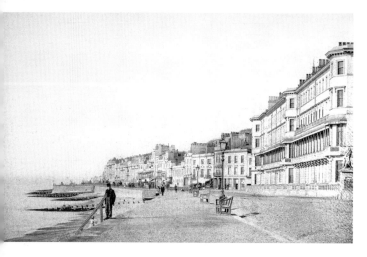

Carlisle Parade, 1857. Built in 1850, this was originally the 'America Ground', so-called because in a notorious incident, squatters living in shacks declared independence from the borough by hoisting an American 'Stars and Stripes' flag. Lord Carlisle, the Chief Commissioner of the governmental department of Woods and Forests, appropriared it as Crown land in 1836.

Robertson Terrace, 1895.
The goat cart was used to
entertain children and is not
for transport. The entrance
to the Albany Hotel is in the
background. It was bombed
on 23 May 1943.

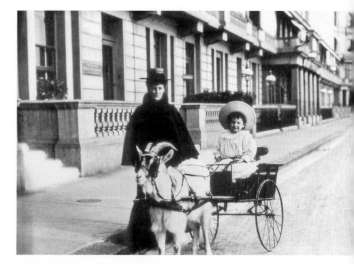

**White Rock at the
entrance to Robertson
Street, 1959.** You could
mistake this for a pre-war
picture, but the short skirts
give it away. Some of the
cars look pre-war, but the
others are definitely 1950s.

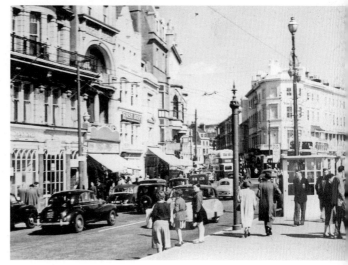

**The pier from White
Rock, 2002.** This shows the
pier after the 'Ravenclaw'
(not to be confused with
Harry Potter!) modifications
that removed the art deco
facade. The poster on the left
is advertising Sussex versus
Kent at Horntye Park and
The Sound of Music is on at
the White Rock Theatre.

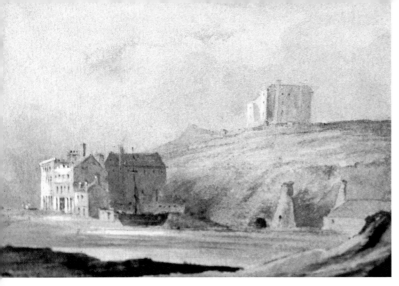

White Rock from the America Ground, 1835. The buildings on top of Cuckoo Hill are the coastguard cottages shown below. The building on the left is the White Rock Brewery, built in 1831.

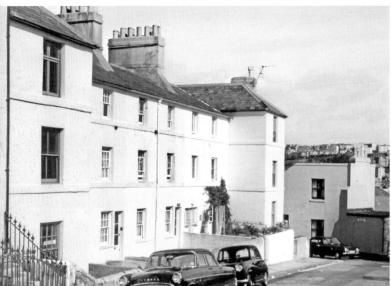

St Michael's Place, 1963. These coastguard cottages, shown on top of Cuckoo Hill in the picture above, were built in 1834. St Michael was a favourite of the Normans and is the town's patron saint. The remains of St Michael's church on this site were removed to build these cottages.

The White Rock itself at low tide in 1832. It was observed at the time that if the White Rock had not been removed by the Corporation, then the sea would have removed it for them.

The White Rock at high tide, showing it disintegrating in a gale, 1830. The rock became dangerous and the last remains of it were removed in 1835. If you ever wondered what happened, now you know.

White Rock Baths, 1963. The children are playing the famous game of 'dodge the waves'.

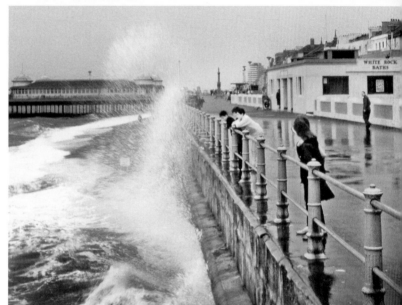

Another view of the White Rock Baths, 1963. Two of the boys were standing in just the right place to get a ducking and have just beat a hasty retreat!

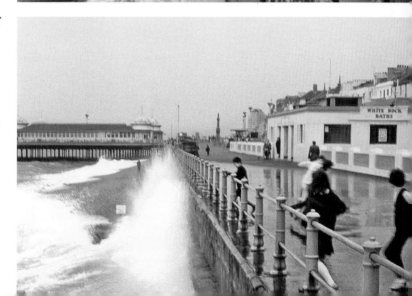

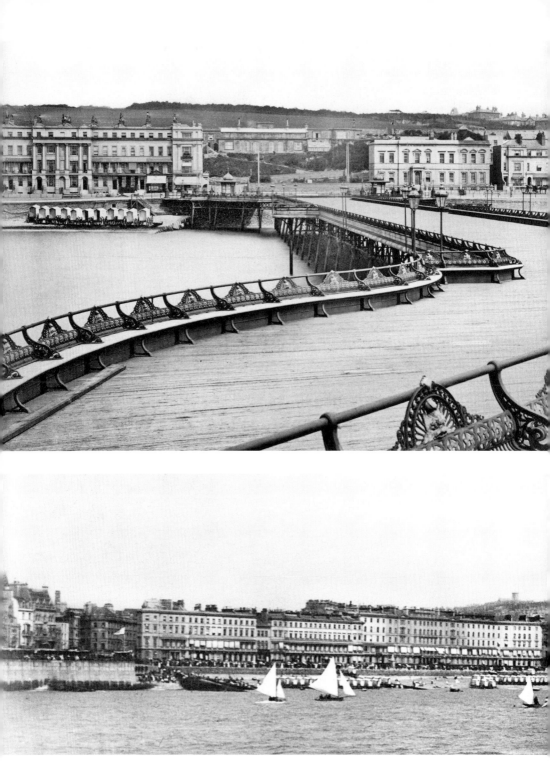

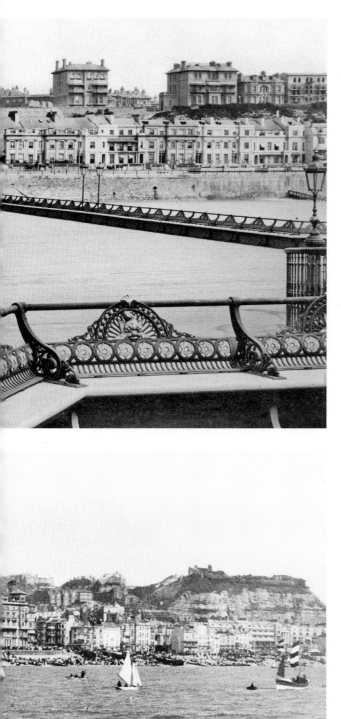

Verulum Place from the pier, 1872. This view is particularly interesting in that it shows buildings that are now all demolished. The building on the left is the Grand Hotel. In photographs taken later than this, two upper floors have been added making the building much larger. It was very badly built, fell into disrepair and could not be saved from demolition. The building standing back from the seafront opposite the entrance to the pier is Lady Jocylyn's Villa (White Rock Villa), demolished in 1913. Lady Jocylyn resided there in 1861–74. In 1889–98 it was used as an orphanage. In 1907 it was sold to Hastings Corporation by Brisco's Trustees.

White Rock Villa is rather puzzling from this viewpoint on the pier. However, when this photograph was taken, there was no left turn up St Margaret's Road – you could only turn right up White Rock Road. The land on which White Rock Villa stood has now been cut away to build St Margaret's Road (the left turn off Schwerte Way). The building to the right of the pier is the infirmary, which was substantially altered and enlarged, as we can see in later photographs from this perspective.

Carlisle Parade from the pier, 1900. Yachts add liveliness to the scene.

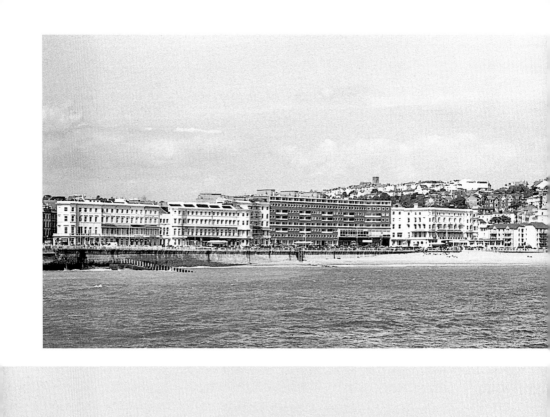

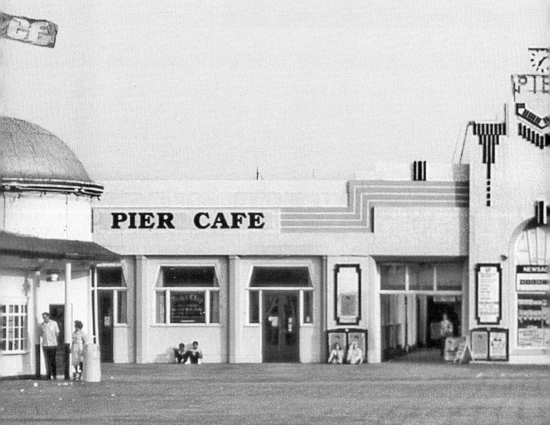

Left: **Carlisle Parade from the pier, 1977.** There are no yachts in this scene because the sailing club moved to St Leonards. This beach is still used by rowing boats.

Below: **The art deco facade of the pier's main entrance, 1977.** This image shows the entrance before the alterations of the 'Ravenclaw' era. The clock is not an original feature. The pier closed in 1999, but was reopened in 2002 by a new owner who transferred it to Ravenclaw Investments in 2004. It had to be closed again in July 2006 due to storm damage, but managed to open again on 4 July 2007. However, on 12 March 2008, two support columns were in imminent danger of collapse following a storm and the pier closed for good. It burned down on 5 October 2010, destroying this facade.

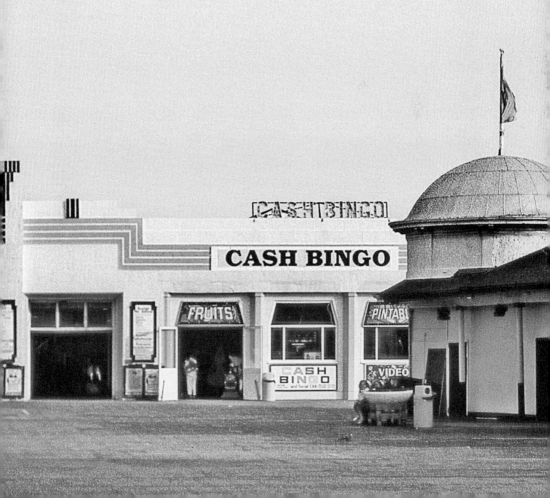

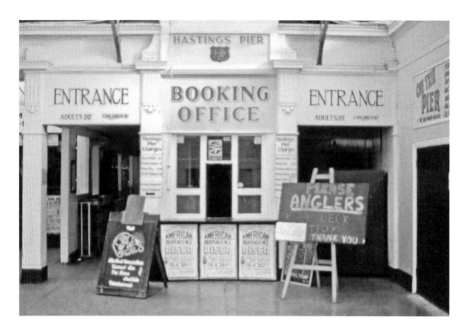

Booking office, 1977. This picture shows a rarely photographed view. On the right is a blackboard that is admonishing anglers to keep the deck tidy. The posters are advertising an 'American Independence Disco' on 4 July. Admission is adults 20p and children 10p. You only had to pay this if you wanted the amusements. There were free amusements in the hall on the right.

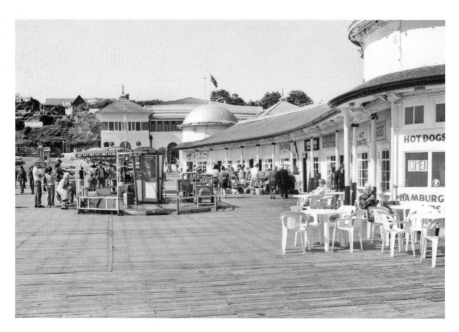

The Eastern Bandstand Shelter, 1977. This shelter was destroyed in the 2010 fire. It originally provided seating for concert audiences and was converted into shops after the bandstand was removed.

A view over the sea, 1977. Just sit and look at this picture to enjoy a lazy afternoon on the pier! Marine Court is just visible on the right of the picture. These plain railings were removed during the last restoration of Hastings Pier in 2015–16. It was planned to clean them up and use them in Alexandra Park. The reconstructed pier has a reproduction balustrade based on the original art deco design that was used at the seaward end of the pier.

The 'Pub on the Pier', 1977. The sign is advertising SKOL lager, which remains popular with pier customers.

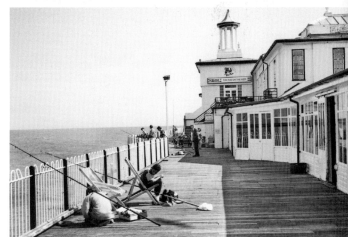

Fishing on Hastings Pier, 1977. The lady has responsibility for several rods that belong to the various anglers who are taking a break. If there is a catch, she will reel it in on behalf of the owner. The building on the right is Pier Ballroom, which was used for concerts. Many famous artists appeared here, including The Kinks, The Rolling Stones, The Who, Genesis, Tom Jones and Pink Floyd to name just a few.

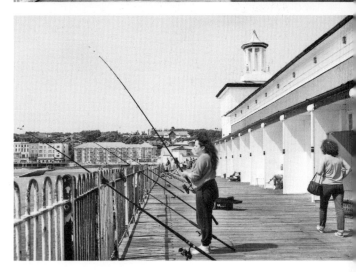

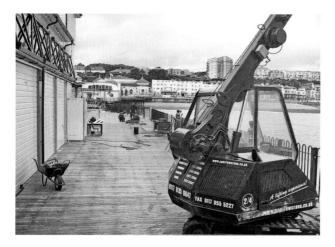

White Rock Place side of the pier during the 'Ravenclaw' renovations, 2007. Compared to the photograph below, the suntraps have been removed. The pier needed millions more spending on it than it was worth and it was forced to close despite the work seen being done here.

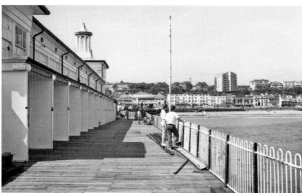

A historic shot of the White Rock side of the pier, 1977. The ballroom has suntraps that are in the shade at this time of day. Both sides of the pier were identical and visitors would go round to the other side to enjoy the afternoon sun. The Royal East Sussex Hospital is on the horizon.

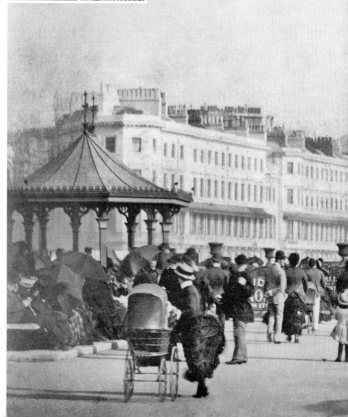

Hastings Pier, 1977. Children enjoying the slide on the pier.

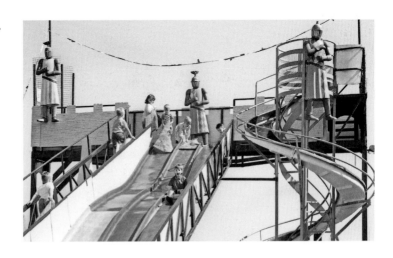

Below: **Carlisle Parade from White Rock, 1884.** This place, where the seafront changes direction, has always been known as 'Splash Point' because it is where children play 'dodge the waves' and go home soaked.

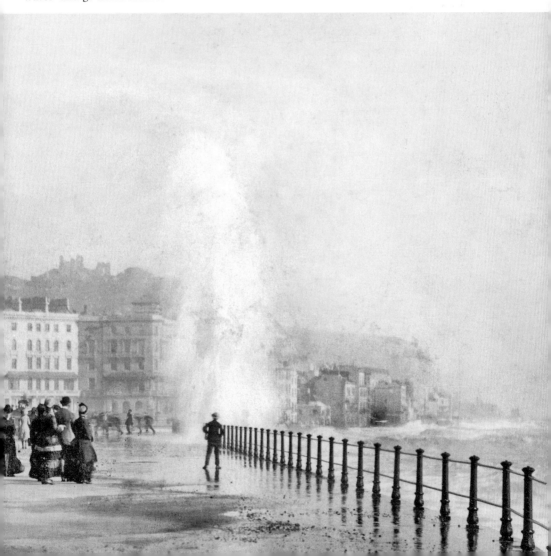

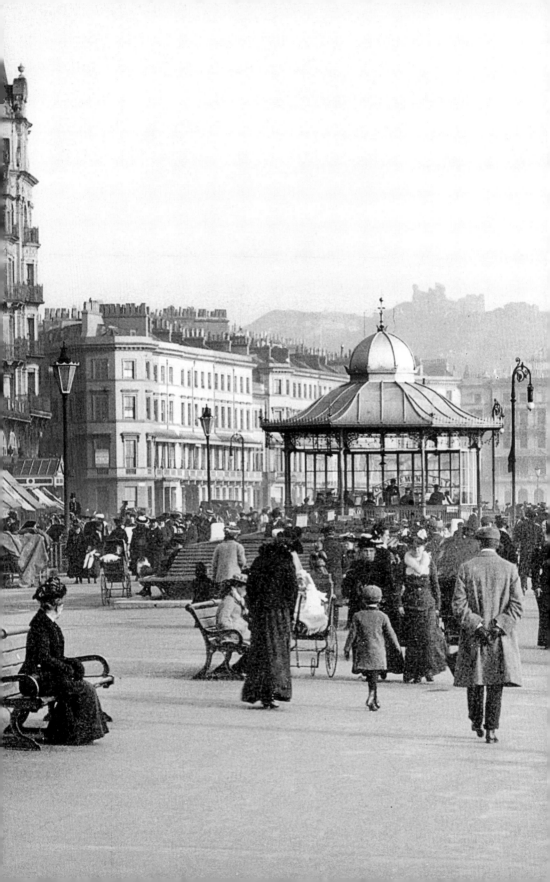

White Rock, 1910. The bandstand was subsequently moved to White Rock Gardens, and then to Warrior Square after which it was demolished.

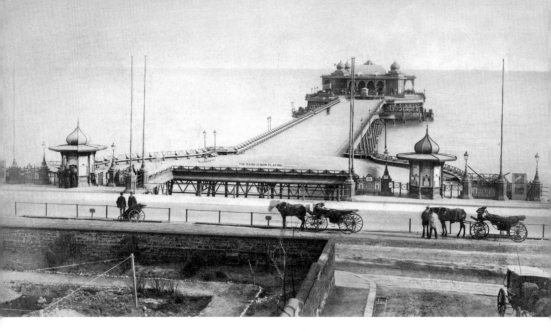

Above: **Hastings Pier, 1875.** Work started on Hastings Pier in 1869 and it was opened in 1872. This photo must have been taken shortly after construction. The grounds of the infirmary are in the foreground. The horses and carts are for rides in the countryside, but there is no queue of customers.

Below: **The pier from White Rock Gardens, 1977.** This is not how the pier looked before it burned down. This photograph dates from earlier. There is a children's slide on the right that appears in this book on page 114. The pier is as short of custom as it is in the previous photograph.

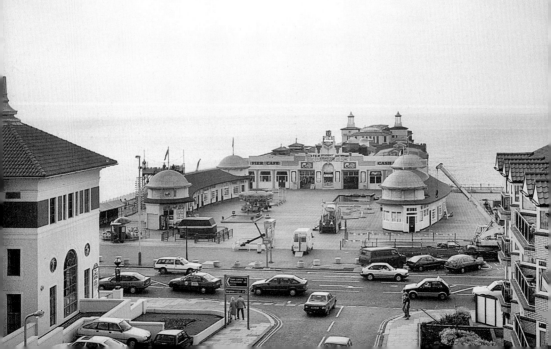

White Rock Pavilion, 1966. The Lord Warden of the Cinque Ports, Sir Robert Gordon Menzies (1894–1978), is at the White Rock Pavilion to be made an honorary freeman of the borough. This photograph shows the entrance to the White Rock before the addition of the portico, which protects theatregoers from the weather, but this modification is not in keeping with the period architecture seen here.

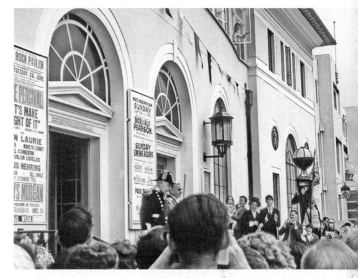

A 1930s bus shelter, 1959. This bus shelter is the only one designed by the Borough Engineer Sidney Little that has not been demolished. He was known locally as the 'Concrete King'. The bus is the number 8 to Cooden Beach. The trolley buses used the old tramway system catenary, which went all the way to the western limit of Bexhill.

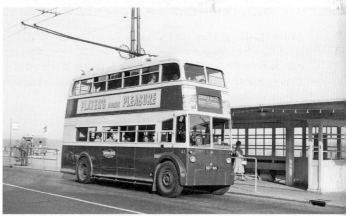

The Yelton Hotel, 1977. This hotel was named after the original hotelier, Mr F.J. Notley, spelt backwards. It has now changed its name to The White Rock Hotel. The Boer War Memorial on the left, which is casting a long shadow in the winter sunshine, was struck by lightning in 1975 and was demolished, but a benefactor paid for it to be reinstated, so it is still here today.

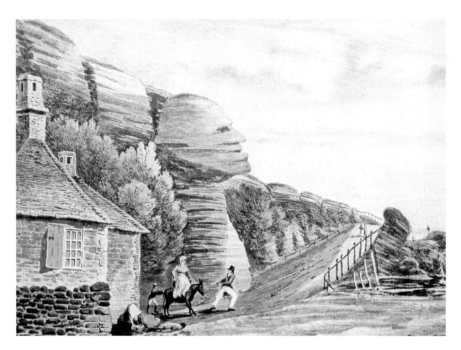

White Rock Road, 1811. This is the location of the 1066 celebrations featured opposite. A man is trying to get a lady to leave her lodging house by donkey to escape from the incoming tide.

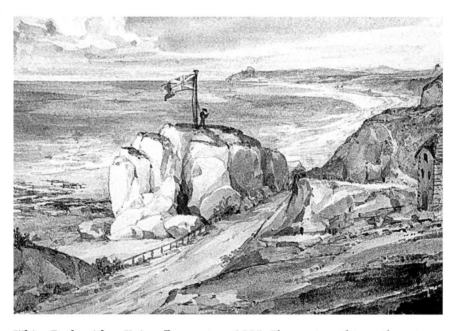

White Rock with a Union flag on top, 1805. The coastguard is on the extreme right. This was important because everybody was afraid Napoleon would invade, but he never attempted it.

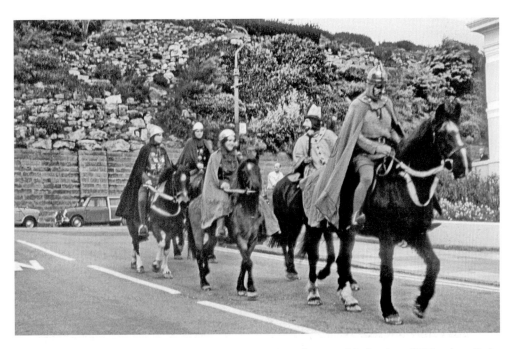

The 1066 celebrations, 1966. It was a Saturday on 14 October 1066 when Duke William's forces confronted King Harold's army on a hill to the north-west of Hastings in one of the most dramatic and decisive battles in English history.

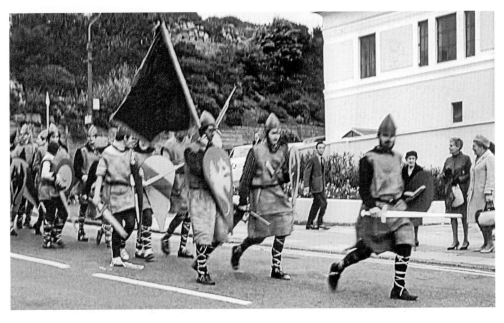

White Rock, 1966. William's forces have come to sort out the Anglo-Saxons, and the man at the front looks as though he means business. Rumour has it that these Normans were undergraduates from Kent and Sussex universities.

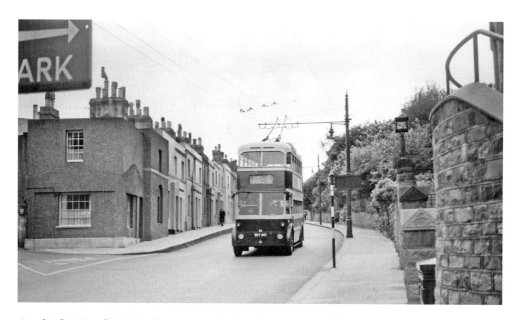

Cambridge Road, 1959. The steps to the demolished Central Methodist church are on the right. This area was originally known as Cuckoo Hill, but this name has no connection with the bird of that name. It was land belonging to the priory and the bailiff was Gilbert Cucku in 1280. The bus is the number 6 to Ore, which subsequently became the 133 service when the trolley buses were replaced by Leyland Atlanteans.

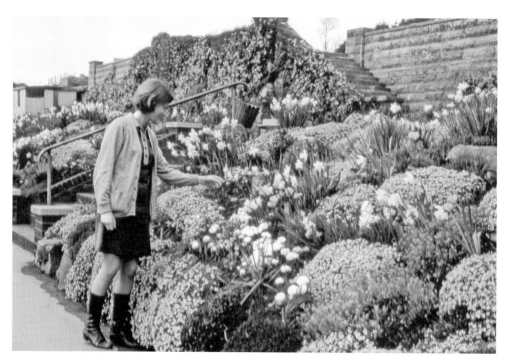

White Rock Gardens, 1963. A lady enjoys a fine display of spring flowers.

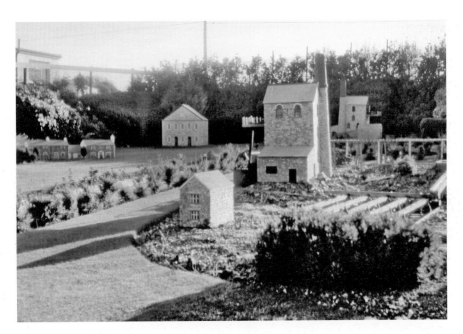

Hastings' model village in White Rock Gardens, 1963. The model village, designed by Stanley Deboo, was opened on 19 February 1955. The models were based on Sussex timber-framed houses. It closed in 1998 after suffering from repeated vandalism. The culprit was never caught.

West of White Rock, August 1811. It is debatable what the building depicted in the foreground is, but it is possibly the church of St Michael that stood on the cliff above White Rock.

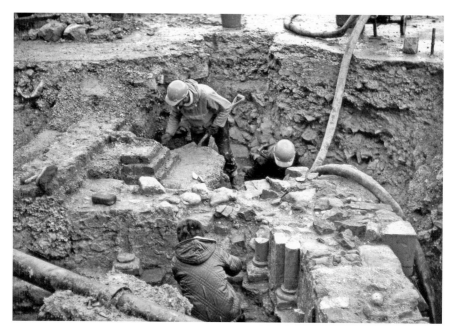

Excavations at Priory Street after the rear of the ABC Cinema was demolished, 1972. The demolition process revealed the remains of the priory of the Holy Trinity. After the Dissolution of the Monasteries, the buildings became a farm and passed into the hands of the Cornwallis family. The east wall of the Chapter House is pictured here. See David Martin's HAARG excavation report, No. 2, 1973. The front of the cinema later became a Sainsbury's store and is now ESK.

Priory Farm barn, 1823. The buildings being excavated above were subsequently adapted for use as farm buildings. They are faintly discernible in the top photograph taken from the castle on page 8 (to the left of the chimney).

7

LAST DAYS OF STEAM AND SLAM-DOOR TRAINS

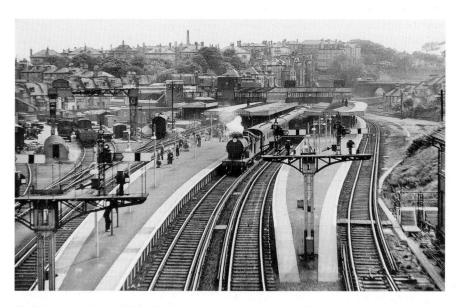

Hastings Station, 1957. The train on platform 2 must be an inter-regional arrival because it is the wrong platform for Rye and Ashford. There is a DEMU (Diesel Electric Multiple Unit) on platform 3, which looks as if it is arriving from Charing Cross as the remaining carriages can be seen in the distance. Visible in the background is Cornwallis Bridge carrying Linton Road across the tracks and the tall chimney at the Royal East Sussex Hospital.

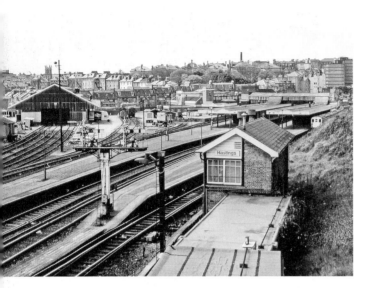

Hastings Station in late British Rail days, 1985. A Class 201 DEMU is on platform 4. The goods yard still has some wagons in it. The 1931 SER signal box remains operational. The tower of the Methodist Central church can be seen above the goods shed.

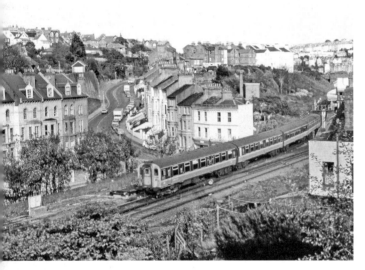

A Class 411 4CEP EMU (Electric Multiple Unit) is leaving for Charing Cross, 1985. The 4CEP (i.e. a Corridor Electro Pneumatic with four carriages) was the first electric train to run on the Hastings Line. The now demolished water tower opposite platform 4 is in evidence.

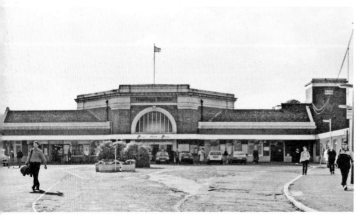

Hastings' neo-Georgian station building (1931–2004) in Connex South Central days, 1985. The railway had just been privatised. There is a similar, but more elaborate, station building at Margate. The lunette window was intended to be adopted as an international symbol for a railway station.

Interior of the neo-Georgian station building, 2003. The ticket office has signs for the '1066 Electrics', which had been recently introduced and is shown in the lower picture opposite. The four screens above the entrance to the footbridge gave information about departures.

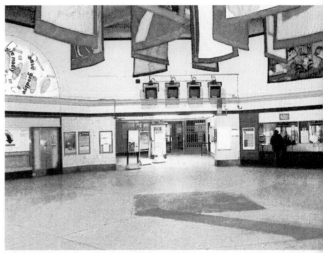

An unusual view of a DEMU leaving Hastings for Charing Cross, 1985. The building on the right was a school. The Corporation Electric Light department is in the arches to the right.

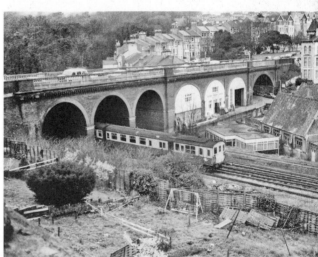

A 'Hastings' DEMU (Diesel Electric Multiple Unit) passes under Cornwallis Bridge as it leaves for Charing Cross, 1985. The now demolished engine shed can be seen in the distance.

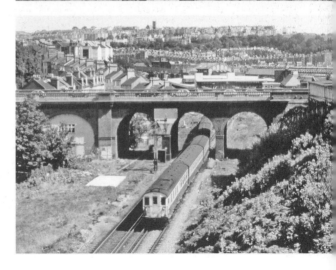

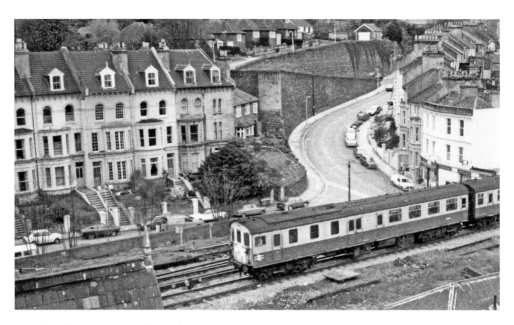

Braybrooke Terrace with a Class 201-202 (6S 6L) 'Hastings' DEMU, 1985. This is before the line to Tonbridge was electrified. The houses on the left have been demolished.

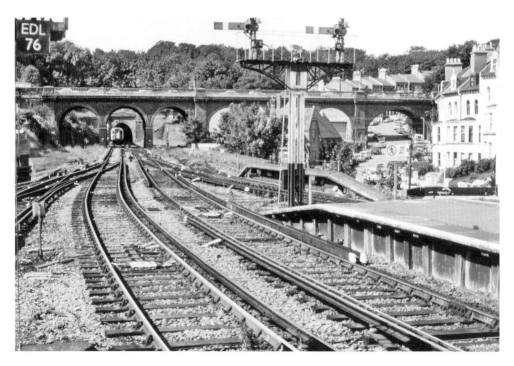

Cornwallis Bridge from Hastings Station, 1985. The track to platform 1 is still *in situ* at this time as are the semaphore signals that have now been converted to colour lights. The houses on the right were demolished by Southern Water because they stood directly on top of a flood relief tunnel.

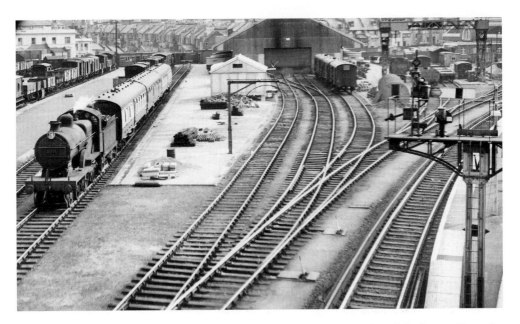

Hastings Station Goods Yard, 1957. The Railway Hotel, now demolished, is visible in the top left of the picture. The station building can just be seen in the top right. The train on the left is waiting in the siding to keep it clear of the main line.

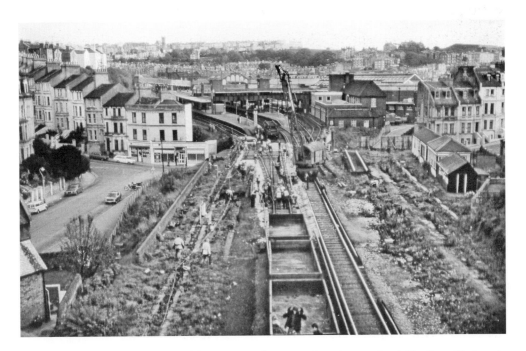

Hastings Station, 1986. This picture shows engineering work at Hastings Station to remove the track to platform 1 in preparation for redevelopment of the station.

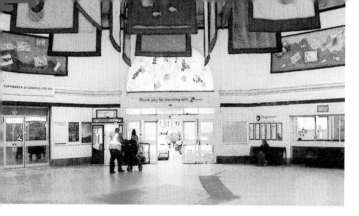

Interior of Hastings Station showing the lunette window, 2003. The buffet is to the right out of view. The station is being used as an exhibition hall for textile hangings and embroideries.

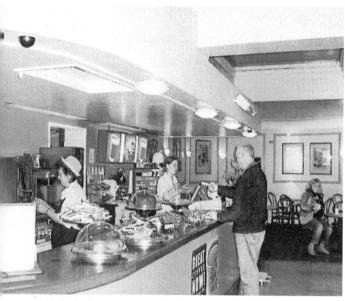

The buffet at the now demolished neo-Georgian Hastings Station, 2003. This buffet had been modernised but it still retains a flavour of its 1930s art deco look.

West St Leonards Engine Shed, 1957. A Class N (31822) and a Terrier tank are side by side. The building on the right is the now demolished West Marina Station. This particular Terrier (32636) is preserved on the Bluebell Railway as *Fenchurch*; it is interesting to see it here.

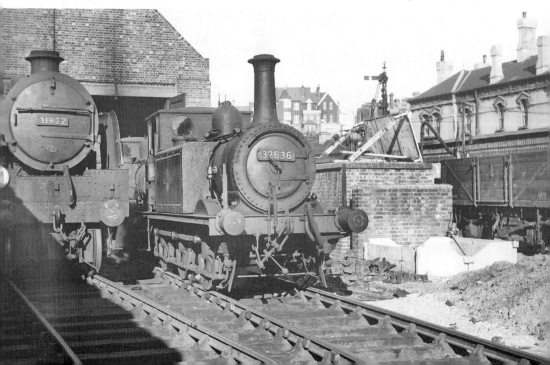

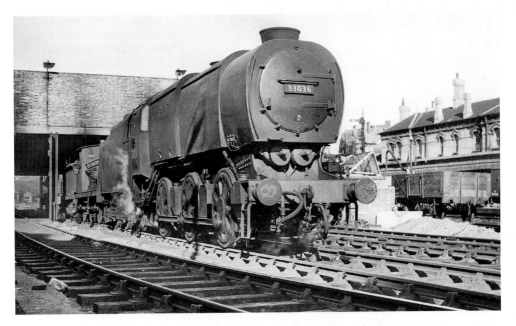

This is a Q1 Class 33036 at West Marina, 1957. These engines were built during the Second World War to haul goods trains. The loco is stripped of all embellishments to reduce the cost. Only one of these locomotives was preserved and it ran on the Bluebell Railway for a time, but has now been relocated to the National Railway Museum.

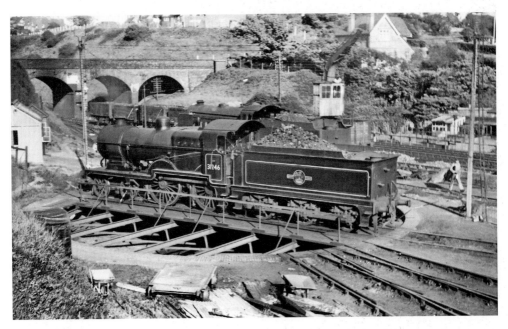

Maunsell D1 Class on the turntable at West St Leonards, 1957. The only feature still in existence is the bridge in the background that leads to West St Leonards Station from St Vincent's Road.

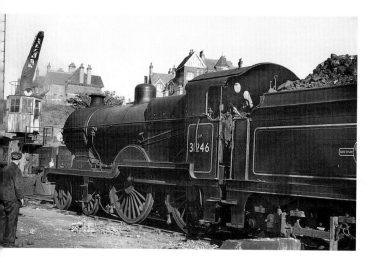

Maunsell D1 Class loading up with coal at West Marina, 1957. The house on the left in West Hill Road is the only thing that remains to identify this location.

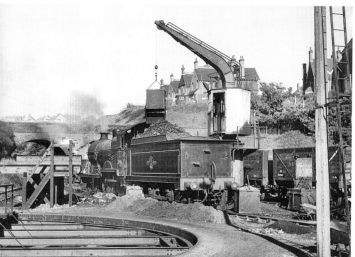

A Maunsell D1 Class coaling at West Marina, 1957. This would make a marvellous subject for a railway modeller. The turntable in the foreground would have had to have been operated by two men. A few turntables could be connected to the locomotive and turned using the pressure of the steam, but this is not one of them.

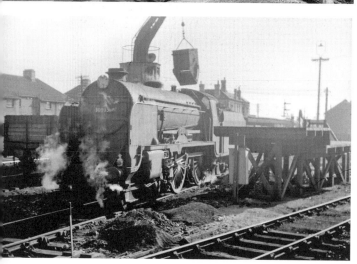

This is Schools Class *Sevenoaks* coaling at West Marina, 1957. This photograph is looking in the opposite direction to the view above. It is a contre-jour shot, with the sun setting over the South Downs.

8

ST LEONARDS AND
SILVERHILL

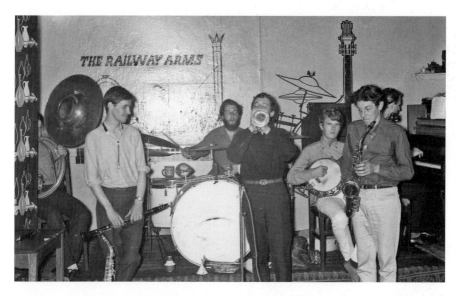

Railway Arms Jazz Band, 1959. This venue, which has now been demolished, was
adjacent to Warrior Square Station. It was the British Railways Staff Association Club
house and not a pub as you might think.

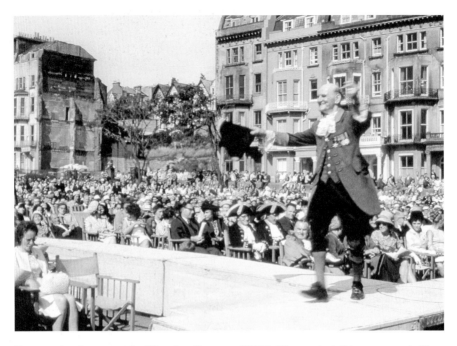

Town criers' contest in Warrior Square, 1966. The contest this year was held as part of the 900th anniversary of the Battle of Hastings celebrations. Second World War bomb damage to Warrior Square is evident in this photograph.

St Leonards, 1980. At first glance this looks like a recent view, but the pier is intact. Residents of St Leonards were always complaining about the clock, in the centre of the picture, which never told the right time. The council eventually replaced the mechanism after it had been wrong for many years.

St Leonards Gardens, 1977.
The gardens were created using a
natural ravine and were deliberately
designed to entice visitors with this
Gothic fantasy clock tower. It was
threatened with demolition, but
the Burton's St Leonards Society
managed to get it restored in 1975.
The gardens originally included a
popular maze, after which Maze Hill
is named.

Bohemia Farm, 1802. The ponds
were used for breeding fish. The
perspective of this view is easy
to determine once you realise
that Hastings Castle is in the
background.

Bohemia Farm looking the opposite way to the view in the previous picture, 1813.
Stell's *Guide to Hastings*, 1794, notes that a farmhouse called Bohemia was famous for its
cream, tea and syllabub parties held in the open air, Gypsy or Bohemian fashion.

View of Hastings from Bohemia Farm, 1820. We can see that only a part of Wellington
Square has been built at this time. We can also get an idea of the reasoning behind the siting
of Hastings Castle with its strategic and commanding view of its surroundings.

Bohemia Farm map, 1858. This map shows the relationship of Bohemia Farm to the railway tunnel and you can easily work out where it was. This viewpoint has not been built over.

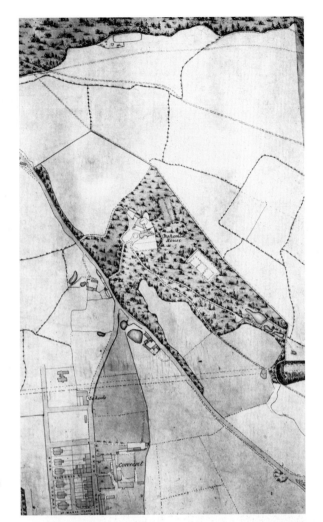

London Road, 1959. Christ Church Hall is behind the bus. It was the original Christ Church and was incorporated into the larger building as the Church Hall. The rooms above were originally Christ Church Primary School.

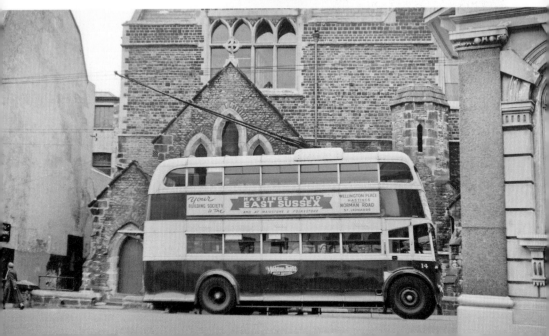

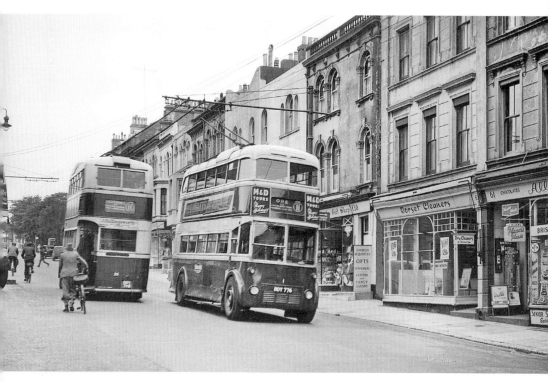

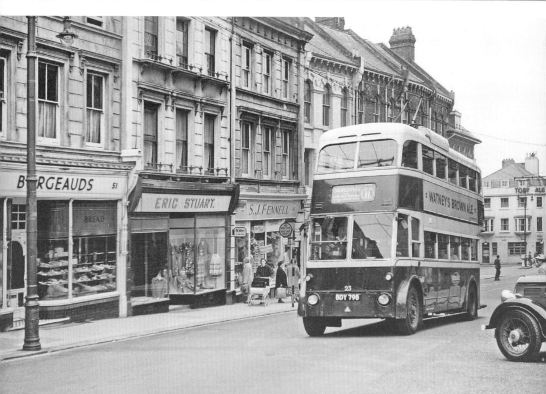

Opposite top: **London Road, 1959.** The trolley buses mainly used the wires from the old Hastings Tramways system, but the system was extended in a few places. The bus on the left is coming down Pevensey Road where the overhead pole often annoyingly became disconnected from the wire. It was a three-man job to re-attach the pole, which always meant a delay, since the third man had to be sent out from the depot at Silverhill. This was a serious drawback with the trolley buses as a bus that becomes disconnected from the power supply cannot move and is an obstruction to other traffic.

Opposite bottom: **London Road, 1959.** BDY 798, which was trolley bus number 23, has just left the stop outside Christ Church for Silverhill. Bergeauds on the left is a baker's. The shop next door is an outfitter's.

Above: **Grosvenor Crescent, West St Leonards, 1959.** Our photographer is returning home after visiting West Marina Station and took this picture as he approached the bus stop on the left.

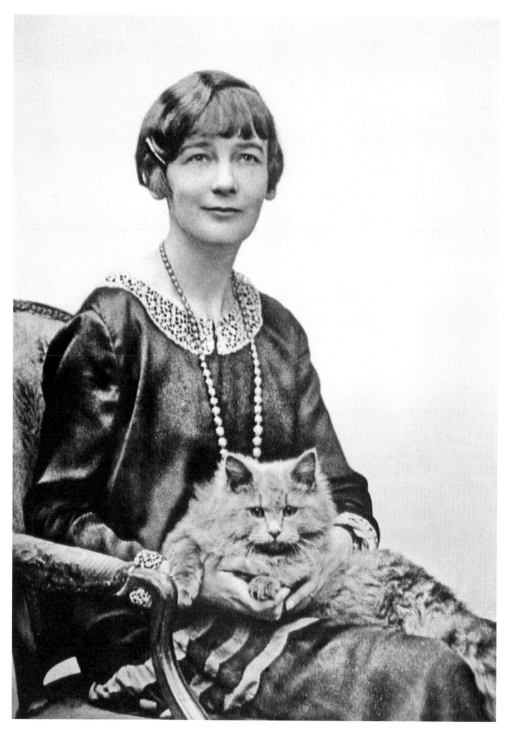

Sheila Kaye-Smith, who lived on the other side of Dane Road to the house pictured opposite, 1922. Sheila Kaye-Smith was a well-known local novelist in her time, her best-known novel about Hastings being *Tamarisk Town*. Her books are now out of print.

'Levetleigh', No. 27 Dane Road on the corner with Brittany Road, 1980. This house replaced the rather grander former house, destroyed by a fire, that was the home of Arthur Phillip Du Cros, the then MP for Hastings. On the night of 15 April 1913, it was fire bombed by a suffragette who was never caught. Sheila Kaye-Smith was blamed, but she would never have done such a thing. Many local people claimed to know who really did it and rumour has it that the culprit was a schoolmistress from the nearby school in Tower Road who was a suffragette. It has now been demolished and replaced by a block of flats.

This mysterious photograph is of No. 241 London Road, 1970. This was where Bob Noonan lived with his daughter, Kathleen, in the top flat where *The Ragged Trousered Philanthropists* was written. There is now a plaque on the wall beside the door to mark the spot. Having taken your 'then and now' picture of Levetleigh above, walk down Brittany Road, and turn left. This location is a short distance up London Road on the right.

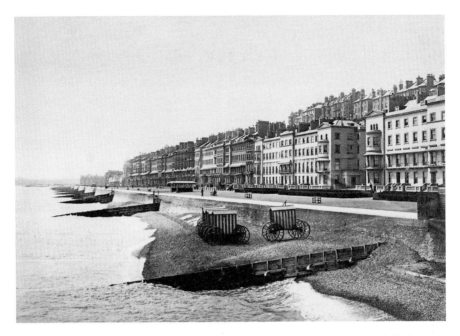

St Leonards Marina from St Leonards Pier, 1891. This photograph looks west along the seafront.

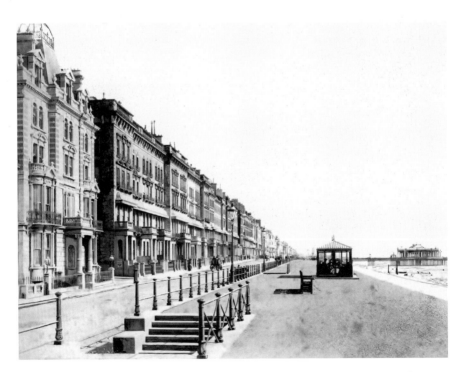

St Leonards Pier from the marina at Sussex Road looking east, 1891. This part of the seafront has survived intact. The building on the left was a hotel.

SILVERHILL

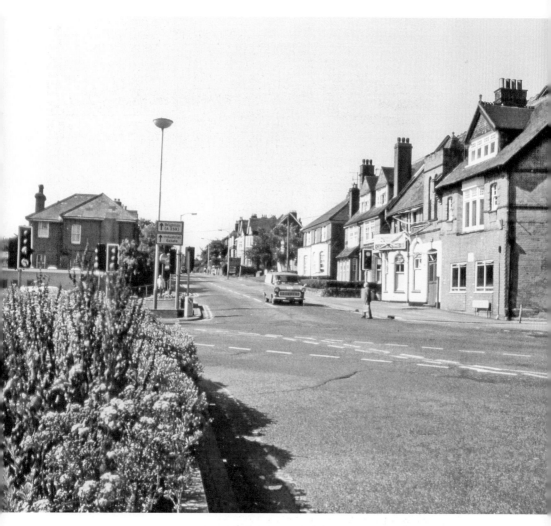

Silverhill Junction, 1966. Note the almost total lack of traffic! All trolley buses headed for the depot at Silverhill on their last journeys of the day, just as modern bus drivers still do today. Silverhill is today the town's most notorious junction, which is always extremely busy and where many drivers experience delays.

Silverhill Junction, 1959. The Corner House Hotel and Grill has now been demolished, making this an interesting 'then and now' subject. The houses behind on the left are still standing in Sedlescombe Road South. A public convenience was built on this site, but that has now been turned into an estate agents office.

Beaufort Road Trolley Bus depot, 1959. The building is still in use as the headquarters of the local bus company. It looks very neat and tidy in this picture.

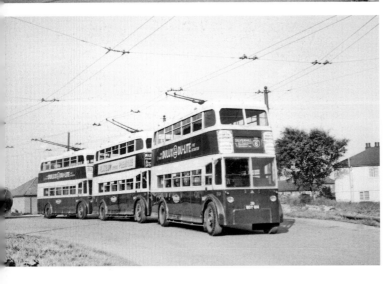

Trolley bus number 39, BDY 814 heads this trio parked in the bus depot off Beaufort Road, 1959. Only four buses from this original fleet were preserved.

A brand new Leyland Atlantean stands to the right of the trolley bus (Number 18, BDY 793) it is going to replace, 1959.
The Atlantean is advertising Longleys, which was a shop in Bexhill.

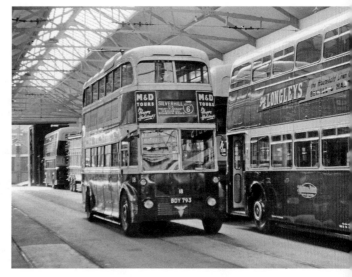

A closer look at trolley bus 39, BDY 814, 1959.
The decision was taken to withdraw all the trolley buses on the same day and replace them with diesel-powered Leyland Atlanteans, which were faster and did not need overhead wires.

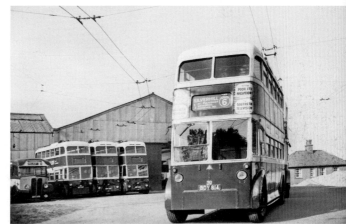

***Happy Harold* brings us to the end of our journey in space and time, 1959.**
The bus behind the thirty-one-year-old pioneer is a Leyland Atlantean, apparently the 88A to Wishing Tree and Mount Pleasant. There was no such bus route as this, so the destination blinds must have been left at this random but surreal setting.

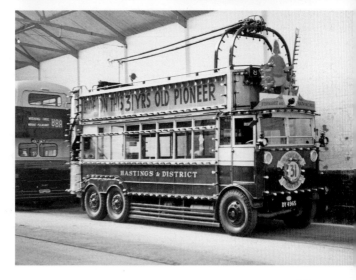

Hastings Carnival, Swan Float, 1963. This carnival was organised by Hastings Round Table, but is no longer held. The town is now known for its more exuberant Old Town Carnival. Visitors still flock to the town on high days and holidays. Although it does not attract the numbers of the past to its traditional seaside attractions, Jack-in-the-green,

Bonfire Society processions, Bank Holiday Bikers and Pirate Day festivities are all well known and well attended, carrying on the tradition of Hastings as a well-loved and popular seaside resort.